# ESCAPE OF A BLOCK ISLAND ARTIST

# ESCAPE OF A BLOCK ISLAND ARTIST

*An Autobiographical Introspection*

TED MERRITT

authorHOUSE®

AuthorHouse™ LLC
1663 Liberty Drive
Bloomington, IN 47403
www.authorhouse.com
Phone: 1-800-839-8640

© 2014 Ted Merritt. All rights reserved.

No part of this book may be reproduced, stored in a retrieval system, or transmitted by any means without the written permission of the author.

Published by AuthorHouse 06/09/2014

ISBN: 978-1-4969-1848-2 (sc)
ISBN: 978-1-4969-1849-9 (e)

Library of Congress Control Number: 2014910453

Any people depicted in stock imagery provided by Thinkstock are models, and such images are being used for illustrative purposes only. Certain stock imagery © Thinkstock.

This book is printed on acid-free paper.

Because of the dynamic nature of the Internet, any web addresses or links contained in this book may have changed since publication and may no longer be valid. The views expressed in this work are solely those of the author and do not necessarily reflect the views of the publisher, and the publisher hereby disclaims any responsibility for them.

To Janet Merritt, my wife and best friend,
and David Merritt, my son

# Contents

| | | |
|---|---|---|
| Introduction | | ix |
| Chapter 1 | Painting | 1 |
| Chapter 2 | Escapism | 14 |
| Chapter 3 | Wildlife Escapism | 23 |
| Chapter 4 | Escape from What to What? | 27 |
| Chapter 5 | Religious Escape | 36 |
| Chapter 6 | Escapism in Business and Culture | 41 |
| Chapter 7 | The Escapee (Me) | 45 |
| Chapter 8 | Arizona | 65 |

# Introduction

This small book has three strands. First, it is about escaping from the workaday world. Second, it is about using art and to some extent music to escape; and it is about Block Island, Rhode Island, which is a popular tourist escape destination.

Block Island, referred to by some as one of the five most beautiful places in the world, is an outdoor paradise well worth a visit. With a setting fifteen miles due south from Rhode Island out into the Atlantic Ocean, it offers its entire perimeter of beaches and bluffs to the public as well as its interior greenway walking trails. Approximately 43 percent of the island land is open space. It is therefore no surprise that the island population swells from approximately a thousand in the winter to more than fifteen thousand in the summer.

The painting on the cover depicts a double-ender sailboat of the type that Block Islanders used in the 1920s and 1930s. Block Islanders used the double ender to fish and travel back and forth to the mainland. The boat is remembered in the Block Island annual Fourth of July double-ender parade as a small, versatile craft that could sail well in heavy air, be hauled out on the beach for safekeeping at night, and could carry large loads of fish.

The hull comes to a point at the bow and again at the stern to split the waves breaking in the front and back. It carried stones from the beach for ballast until they were jettisoned and replaced by a like weight in fish.

From twenty-five to forty feet in length, with a crew of two, this was the only mode of transportation to and from the island for many years.

The painting reflects an image in my head, and I created it on an eleven-by-fourteen-inch canvas in heavy body acrylic. The robust and

almost primitive style of the art is offered to represent the weather-oriented life and nature of early islanders.

I often escape from daily life by imagining my hand on the tiller of this boat in a storm. It was with that feeling that I used the paintbrush to cut the unique curves in the painting. In this book I talk of looking into one's head for escape, satisfaction, and comfort. Most Block Islanders, because of the nature of their isolation, also have learned, in my opinion, to look inward for satisfaction and comfort and to escape.

During the past decade, I have come to know Island visitors as a resident, as a water taxi driver in New Harbor, and as an artist in the Spring Street Art Gallery. It appears to me that most people come to the island with visions of escape in their minds.

Island visitors and residents, for the most part, have chosen to escape from the mainland—or America, as Islanders describe it—to enjoy a more relaxed life surrounded by the Atlantic Ocean. *Willy-nilly* describes life on the island, spontaneous and haphazard!

This story is autobiographical with a philosophical flavor. The paintings reproduced in these pages are my interpretation on the escapist theme. The paintings argue that for me becoming an artist was a good way to escape. Singing was another! Singing and painting are two of the ways I have chosen to escape.

When painting, I never use a photo or any other document to guide my artistic production. Reaching into my head has turned out to be fun, and writing about escapism has also turned out to be fun! I conclude that it is fun to escape! Perhaps an exploration of what is in your head will result in a new artistic pursuit!

# Chapter 1
# PAINTING

In retirement, as part of my efforts to cut off the demands of my previous vocational life and learn more about myself, I picked up a brush and started painting. The impetus to paint was my love of color, particularly how color relates to light and the absence of light. After a quick journey through the media of watercolor and oil, I found myself enjoying the new open and liquid acrylic paints. Color wheels were only slightly helpful as I learned about conflicting color relationships, and I wound up relying on instinct and confidence to produce the desired color. The new acrylics allowed me to mix on the canvas and overpaint as my spirit dictated.

With a box of old acrylics, which were less vibrant and quicker drying than the new ones, I could keep a mix going on the canvas, using water spray if the process took a while. I experimented with a wide range of gels and heavy-body paints to produce depth, shine, and topography. I am not a cook, but I imagine that painting is a bit like cooking, where you add ingredients and then taste until you get it right!

To apply the paint, relying on my architectural and engineering background, I used bright brushes for control and accuracy. In my realistic stage, if I wanted to make a boat look exact, it didn't go well. The boat's delicate lines were shaky, and the end product was not quite right.

As in house painting, a good, pure bristle brush that kept its shape could do most everything, so I almost exclusively began using quality round brushes with sharp points. It was with the relatively big, round brushes that I learned to layer and cut in, just letting the paint flow.

Along the way, however, I gave myself permission to use any type of tool. For instance, I loaded pallet knives with paint, using their sides to make lines and slopes and their points to make marks. I used a toothbrush to make dots as in snow and used magic markers and ink pens to make lines.

A black ink pen with a fine point that I use to make notes in my sketchbook became one of my favorite tools. With the pen, my boat lines became sharper and a lot more satisfying.

Dry brushes and dry cloth were useful in cleaning up messes on the canvas. The fan brush turned into a major asset. I learned to dry the fan brush and pull the paint, making pine needles or other thin lines, such as sea grass. I also used the brush to swirl paint when making waves.

## My Father

My father was an engineer and became an artist in his retirement. He was a realist and would make copious notes on color mix before starting to paint. During his lifetime, I was unaware of the planning that went into each of his works, but shortly after his death I came upon his notebooks of data and then understood.

Today, I keep two of his paintings in my home. They are both seashore scenes and provide me with considerable comfort. They have soft black frames surrounding sand and water. I wonder how much of what he did and what I do is genetic. His work is quite good and gets better as it and I age!

Noticing that his oil paintings had started to crumble and that in spite of periodic cleaning with a cloth the paintings were deteriorating, I decided that the paintings needed attention. So I took soap and water and gave the canvas a good cleaning and then took out my acrylics. Feeling I was being somewhat sacrilegious, I only slightly changed the shade of the sky and water. I filled in the cracks and then took the paintings outside and sprayed them with varnish. Amazing! They looked better, and my confidence in the restoration process improved! During the restoration process I looked carefully at his painting technique, and my respect and admiration for his work increased. That was a good feeling.

## The Mind's Eye

Grace Luddy, who lives on Block Island, is a photographer who majors in wave pictures. Her high-powered camera and enormous printer produce astounding results and eclipse any realistic effort that I might make to paint waves. But she cannot take a picture of things she cannot see, and I can! Is what is in my head worth reproducing? Clearly, I can make color combination abstractions consisting of slapping paint in various directions and appreciating combinations. The results, however, are not satisfying, because they really do not communicate on the desired level.

To remedy this, I began painting realistically and then converting the realism to abstractions with color overlay. Observers liked this technique, because there was a hidden story in the painting. It is fun to find buried realism. I did a large blue marlin jumping into the sun from the ocean's depths and didn't like it, so I took a knife and mixed up both the ocean and sky and introduced a sharp orange-red blood spot superimposed on a sharp yellow patch. This abstraction indicated that the fish was being caught and was bleeding. We hung this painting in the foyer and liked it. Son-in-law David Lambert also liked it, so it is now in his house.

I like the idea of depicting impressions of things that a photographer cannot capture with a camera. My favorite at the moment is an abstract painting of a vertical sperm whale in the depths of the ocean in a mortal fight with a great white squid. The paint has been slapped on the hardboard on top of black gesso and stands out in an almost supernatural way. I have used liberal amounts of white and blue, knifed on to give the fight some texture, and I have brought the depths of the fight to the surface from my mind's eye. As background, I have read about the great white squid and the great sperm whale, but the painting is unique primarily because of its color application. It is designed to stand the test of time.

## Black Gesso

A local painter was proud of the fact that she never used the color black. She claimed that the color black was the absence of color and therefore not a valid expression.

I, on the other hand, liking the black frames on my father's paintings, rationalized that the juxtaposition of black against color was meaningful. The stars at night, particularly in our unpolluted Block Island sky, are wonderful because they evoke the thought of a prick of life against a sea of nothingness.

I inherited a jug of black gesso and, in a moment of creativity, started to use it as a prep paint. I decided to deal with the rough canvas surface problem. I had been trying to fill all of the little canvas holes with the gesso, but it wasn't working. Thus I began the search for a smooth surface and found myself at Home Depot in the lumber department, where I came upon hard board. About one-quarter of an inch thick, it seemed like a good, smooth surface, and the saw operators at the store would cut the four-by-four sheets into any number of smaller pieces for free. Also, I could paint on a big piece and let the painting take its own shape and size and then cut the wood with my jigsaw to the desired size.

## Liquid Acrylic on Yupo Paper

As I've said before, to remember, interpret, and generally appreciate the island's beauty, I escape into my head, trying to paint what I think. What follows is a description of my latest painting process. To start the process, I usually separate the painting into simple parts, such as sky, water, or beach, and sketch in a delineating pencil line.

Then comes the exciting part where I look into my head and then squirt little piles of paint related to each section on my pallet.

I mix until I get the right shades and then put little piles of paint on Yupo paper. This paper is like photo-developing paper and is very slippery. I then pull the color together with my eight-by-one-inch pallet knife. If I am doing the sky, for instance, I mix the piles of paint and stop immediately when the product looks good. I can tinker with the product, but usually the first shot is the best. I know that I can move paint around with water and that, if necessary, I can overpaint. Many squirts of water into liquid acrylic will make the paint puddle. Also, the water will hide under a skim of paint and take its own good time drying.

If I am trying to paint a water scene, I lay in a dark horizon and then use a combination of fan brushes and pallet knives to pull the water in an appropriate direction. This part of the painting process is very kinetic. I actually feel the motion of the water and connect with

colors that exist in my mind's eye. If I am doing a beach, for instance, I feel and see a combination of water and sand and blend it with a combination of kosher salt, a sponge brush, and a paper towel. If I am doing a field of flowers, I cut the stems and rough in with a fan brush and then dot the flower colors in with a small regular (bright) brush. The whole process is quite simple and fast and relies on planning the picture and knowing how the colors blend and function. The fun is that I don't copy a picture but instead rely on my memory and instinct. The process is very spontaneous.

This is an abstract I painted and had photographed and developed on polished aluminum, an eleven-by-fourteen-inch painting done on Yupo paper and entitled *Poppy* by Janet, though I originally called it *Embryo*. The technique calls for spilling some liquid acrylic and spraying it with a little water so it rolls around and paints itself into an abstract. You can stop the rolling around with a paper towel or a brush, but the painting will lose its right-from-the-chicken quality.

In the gallery we had a customer who liked this kind of abstract. At home painting one day, quite by accident, I hit the tall brushes that were in the water jar, which spilled onto the pallet paper in the tray. I realized that the mess was beautifully delicate. I framed it and sold it to the customer who liked abstracts. This is not hard to do—spill, frame, and sell! The aluminum reproductions are weatherproof and perfect for a patio.

## Typography

To provide some texture to the relatively flat product that comes from putting very smooth and liquid paint on very smooth and shiny Yupo paper, I often use modeling paste as a base or just use heavy-body acrylic paint and apply it thickly with a pallet knife or a heavy-duty brush. Sometimes I make wave spray with a toothbrush. If I am doing a large abstract, I use what I call schoolboy paint (nonprofessional and more economical) as a base and then cover it with high-quality professional paint. When all is said and done, I finish off with a high-quality art varnish.

## Color

Each art project has its own color scheme. When painting a wave, for example, I usually set the wave or waves against a dark horizon and then plan in a breaker or wave tip line. I like dark turquoise blended down to very white turquoise where the light is reflecting through the thinness just below the breaker line. If the wave is coming into the beach, I mix the greens with titan buff or bronze interference paint to create sandy water and then pure browns with kosher salt to give a sandy beach quality. Also, before finishing off the water scene, I add some magenta

very lightly. I make the actual surf of the breaker with pure titan white paint and just chunk it on with a fan brush.

## Movement

Each painting has its own movement pattern, but normally the motion goes from the upper left corner to the lower right corner led by brushstrokes and from dark to light. There seems to be some rule in my brain that calls for left-to-right thinking as if reading a book.

## Framing

The Island Art Coop likes to have its paintings framed, and I recognized that a frame was part of the product. However, I didn't like the ornate frames and mats that, in some cases, seemed to take away from the stark message of the actual painting. Therefore, I settled on metal frames that came in a wide variety of colors, were easy to put together, and were relatively inexpensive. I could frame an eleven-by-fourteen painting for less than twenty dollars and could get frame parts for any size painting, allowing me to let the painting determine the frame size. This was particularly good from an economical point of view. Also, as part of my development process, I had become a prolific painter and needed more and more frames.

## Presentation

The framing of the painting is a major part of the presentation and should be done with thought and care. I like a solid frame with double matting of the appropriate color, foam core backing, and a quality no-glare acrylic glaze. Everything should be acid resistant and put together with solid fastening and a vinyl-covered hanging wire. I sign and date all my work in small print and tape the back of the frame so dust cannot enter. When I present a painting to a person, I want the back to be as pleasing as the front.

All of the above should be affordable, easy to produce, and part of an enjoyable process. It is fun to stay in touch electronically with owners of my work, and it is fun to give paintings away and leave a piece of my thinking to become a part of somebody else's thinking and life.

## To Sell or Not to Sell

It is difficult to figure how good you are as an artist, especially if you do not have a clear personal definition of what good is. And yet it was clear to me, after people finished being nice and made meaningful comments about what they really liked and really didn't like, that my work had some quality. Given the circumstances, I could sell my work at the Island Coop or give it away.

Armed with a thirty-six-by-twenty-four painting of a swordfish boat, I asked the local maritime institute if it would like to have it for their silent auction. They wanted it, and now the painting has a new home. I was told that the buyer considered this painting as the work of the "next great primitive island maritime artist!"

The word *primitive* raised questions in my mind. Was I really that primitive? Should I capitalize on the idea of becoming a primitive artist? No, I rejected the idea. Being a primitive artist was just a part of my developmental process.

## Monopoly Money

At some point I came to the conclusion that realistic primitives had sentimental value as opposed to monetary value. I made plans to auction some off at a summer family reunion, providing the family members with equal amounts of monopoly money with which to make purchases. The paintings were sure to bring high prices, which would make me feel good. People would get what they wanted and could afford, and the process would have a kind of equality to it. I knew implementation of this idea would be fun.

The giving of certain paintings produces anxiety. Has the painting received a good home? Should I be keeping the painting for posterity's sake? The solution is in the high-powered digital camera. Reproductions by camera and printer can seemingly come out better than the original, because the colors can be tweaked in Photoshop. The blues can become sharper, and the reds can become redder. I let the professionals do the tweaking when they make copies. They keep the painting photos in their files and can reproduce them at a small cost on any surface. Most of my reproductions have been done on canvas and put on stretchers.

A large reproduction of a painting of a breakwater and waves hangs over our fireplace and looks the same as the original. I did the original on tag board primarily because I had some and wanted to use it up. It lacked stability. The reproduction is on canvas on a stretcher and has permanency and stability. The colors do not seem to fade as much as those of the actual acrylic.

## Philosophy

The concept of death also relates to blackness. If, in fact, dying is the transition from something to nothing, then blackness, which is the absence of color, may be the best representation of nothingness.

To assume that something is nothing when it is black would be silly. But if you assume that the absence of color is somehow the absence of sensibility and that sensibility is the essence of the soul, then the departure of the soul is similar to the departure of color. The whole process might be classified as the departure of humanness.

I can easily rationalize that when the life of my body departs a mantle of blackness will descend, and then the only representation of my humanness will be what I have left behind. Paintings, writings, songs, memories, and other similar manifestations will be left behind. I like the idea of interfering with the presence of nothing with the application of color in various forms.

## Heart of Darkness

Joseph Conrad bothered me for some time in my college days with his concepts of destiny and of blackness (darkness) as the core of man's soul. Recently I read his little book *The Shadow-Line*, in which he produces the same dark conceptual moment that is survived by a lonely and young captain at sea. Conrad disavows the philosophic import of this moment in this book, but I think he is not being truthful or at that time did not understand himself.

I took that concept of darkness and painted the tall ship *Black Pearl* on black gesso over canvas in stark white relief with a simple silhouette. The hull of the boat is painted with polypro black boat paint. This painting takes a time-honored tall ship, with which I have had intimate

involvement, and places it into Conrad's vortex of nothingness. The ship and its crew will eventually succumb, but the painting may survive. For several years this tall ship was anchored in Block Island's new harbor. The ship is now somewhere on the Great Lakes.

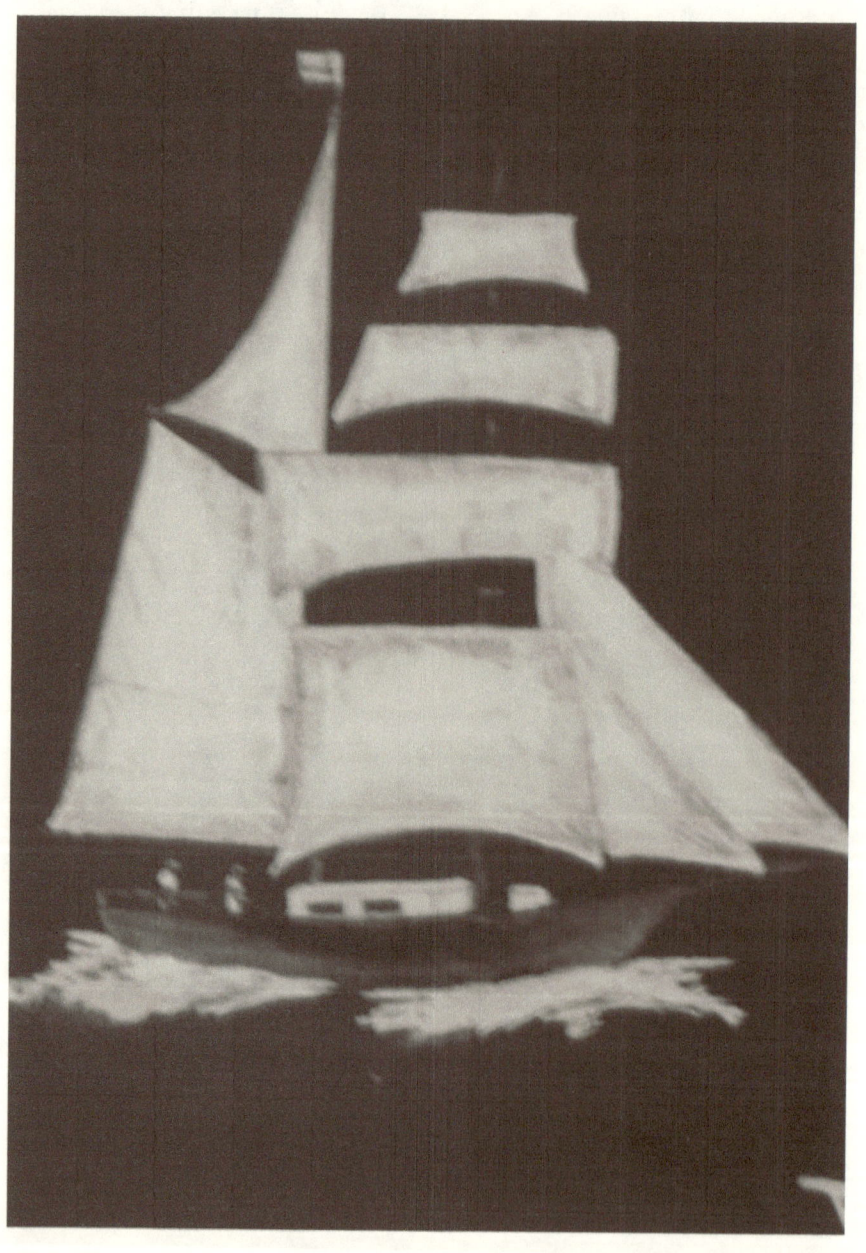

This painting, as described above, was done with white acrylic on a twenty-by-twelve-inch canvas.

Named the *Black Pearl*, this vessel can be identified as a class A tall ship and is known around the world as a hermaphrodite brigantine square rigger. Only seventy-two feet long, this small ship has a record of beating many of the larger tall ships in various races. The Aquaculture Foundation of Bridgeport, Connecticut, which I chaired, owned her for almost a decade. The art world has many *Black Pearl* paintings, and Newport, Rhode Island, has a restaurant named for her.

Is this *Black Pearl* phase of my painting development temporary? Should this phase be called my black period? If I change from this mode, why will I change? I doubt that the black-and-white symbolism will change in my mind, but I am already thinking about using red as a base. I do not understand red, but it stimulates my senses. But I don't think I like red with black, and I know I don't like red and white. But I do like red and green. Why? What is the meaning of that?

I understand the basic color symbolism of green as life-giving and red as virulent, but I cannot find it in myself to give it a philosophical place on the hierarchy of life-related concepts. I wonder if I can do the same comparison with sound and smell.

## Chapter 2
# ESCAPISM

At 4:00 a.m., someone phoned to alert me to the potential of an early-morning snowfall in Trumbull, Connecticut, which might well necessitate the closing of the school system. As the superintendent of schools, I was responsible for the decision to call off school. Another night, as we lay in bed, the phone rang again; this time the call was for Janet, who was dean of students at the University of Bridgeport. She was asked to come to the hospital to be with a student who was seriously injured and not expected to live.

Janet and I came to Block Island, in part, to escape from the mainland pressures and from our lives as educators. Our retirement from these positions happened almost simultaneously, and our move to Block Island was designed to escape not only the pressure of both jobs but the retirement aftermath requiring us to stay closely in touch with our educator friends.

One might expect escapees to have a common bond and a higher level of understanding, but such does not seem to be the case. Sure, the majority of the full-time residents on the island remind themselves with regularity how great it is to be in paradise, when, in fact, they are probably saying, "Let's hang together and make the best of this." Together they bring to the island a wide variety of personalities and cultures. For instance, my ecumenical choir bench mates include a priest, a rabbi, a Manhattan lawyer, a recovering alcoholic, a destitute wanderer, the police clerk, two millionaires, and numerous other types. We make good music together.

## Block Island Escape

Block Islanders refer to their escape from America. On the Island there are no stoplights, no fast-food restaurants, and no neon signs. All the beaches are public and free. The one thousand or so winter residents pretty much all know each other; medical center treatment and rescues are personalized; race or creed play very little role in developing friendships; and islanders (including their dogs) see each other regularly on the one-hour ferry ride to and from the island, in the post office, in the grocery store, at the library, and walking about.

The one thousand winter residents spend their time preparing for the almost twenty thousand summer visitors. Surrounded by pristine public beaches, one would think that the island would be a camper's paradise. But for a variety of reasons, ecological and otherwise, camping is not allowed with the exception of one special place for visiting boy scouts.

Residents are welcome almost everywhere. For instance, we can sing in the ecumenical choir without a tryout, we can belong to the crafts guild, we can become members of the island's art cooperative, and so on. We can attend progressive dinner parties with people we really don't know.

A wide range of town committees keep people busy and socializing. The post office and library provide an important lifeline. But when push comes to shove, we can walk it off on the beach, rain or shine. The weather on Block Island is about six degrees warmer in the winter and six cooler in the summer than on the mainland.

When it is suggested to tourists that they move to the island, the usual rebuttal is, "But what would I do with myself in the winter?" The answer, of course, is for them to learn to escape from the self that is afraid of being isolated on an island and find the personal resources and time to enjoy their own various capacities. In the process, they would find the essence of their lives in the so-called Block Island paradise. The resilience necessary to live happily on the island is made up of a willingness to leave family and friends on the mainland.

## Resilience

An ocean island, by my definition, is far enough out so you can barely see it from the mainland and unprotected so it is buffeted by ocean wind and waves. One evening when I called from the mainland, Janet, who was at our island home, asked a penetrating question. "Are the windows supposed to be bending?" she said. "I can see my reflection wobble on our glass patio doors."

"How hard is it blowing?" I asked. She responded that the anemometer showed gusts to eighty miles per hour.

I explained that the windows were designed to buckle and suggested that she relax and enjoy the pleasant wind sounds. She replied, "Okay," and we went on with our nightly conversation.

Because of such weather, the island ferry has to be big enough to brave the elements, carry the freight, including cars, in some form of anticipated comfort. The Block Island ferry system has several boats that meet the requirements. While their capacities vary, they can carry up to five hundred passengers, up to approximately forty cars and trucks, and a wide array of freight and animals. This Noah's Ark type of entourage, steaming in moderate weather conditions at fifteen knots (seventeen miles per hour), can reach the Island in slightly less than an hour.

Summer visitors come for a day at the beach with their coolers or for a week or a month with their SUVs. These trucks roll off the ferry loaded with bikes, surfboards, beach chairs, and dogs. For every day-tripper, we get an overnighter. During the height of the summer tourist season, ferries make up to sixteen visits a day, swelling the Island population to more than fifteen thousand people. In the winter, some days have only one ferry serving the population, which, during February school vacation, can be much less than a thousand.

## The Purple Flag

The ferry company can raise the purple flag, stop transporting, and make sure that folks can't escape. The decision is usually made when wind-driven conditions have unexpectedly worsened or when the weather website predicts a problem. Those waiting to get on the ferry at the mainland dock generally take the purple flag in stride unless they

are headed for a wedding. In cases of real urgency, travelers with a need to get on the island search for a plane ride, or if that is also cancelled, which is often the case, they look for a small boat captain willing to make the run in poor conditions. More than likely, passengers will take their seats on fish crates in a lobster boat and prepare to be sick. Those stuck on the island who accept the travel delay and need accommodations can usually find a bed and some food. Block Island hospitality likes a good storm and understands a visitor's plight. Islanders will often open their homes to a stranded visitor.

Those on the island waiting to get off are usually stuck for an undetermined length of time. Stories abound of plane crashes and shipwrecks related to those determined to brave the elements and get to the mainland. The island has been and still is an amalgamation of friends and foes forced to live together in harmony.

But at night, when the conditions are right, the ghosts rise up and retell their stories. Well documented in the literature are the islanders who built a fire on the north point to trick sailors into sailing onto the rocks. Calico Hill in the center of town is where they dried cloth looted from a wrecked sailboat that took the bait. The ghosts of the sailors of that vessel continue to be regular visitors, and the sailboat can be seen as it continues to cruise offshore.

An *islander* is a year-round resident and a *cottager* a summer resident. Those who rent are called *visitors,* and those who come for a day at the beach are called *day-trippers.* An islander takes the purple flag in stride and settles down to enjoy the storm. A cottager, usually with some shoreside obligations, handles the situation with much less serenity, while other visitors and day-trippers usually enter into various stages of apoplexy. The purple flag goes up and down quietly with little fanfare or warning.

## Mal de Mare

On one of our early ferry rides, we heard a sharp gunshot-type sound from the car deck of the ferry, and I rose from my seat to investigate. The situation was not good. The sophisticated and unsophisticated were sitting together in the spacious main cabin with vacant eyes, clutching their vomit bags or using the floor in a spread-eagled fashion as a repository. The crockery in the food stand was making its own music.

The sea water had found the second level of the boat some twenty feet up as thirty-degree rolls started to take their toll.

Janet and I, together with our island guest, who had been looking forward to three days in paradise, sloshed our way through a mixture of water and vomit to the outdoor side deck to get some air. The waves, at least twelve feet from crest to trough, were approaching us beam on. Water coming from the bow was ankle deep when we rolled away from the sea and over the side when we rolled toward the sea. On a bright note, we could see the island jetty entrance about fifteen minutes away, only to be depressed when an old salt islander commented, "When it gets this bad, sometimes the ferry can't get into the harbor and is forced to turn back."

Recognizing the salty authority of the islander, I asked, "Were those gunshots I heard on the car deck?"

"Nah," he said, "steel straps make the same sound when they break."

At that moment, we took a larger than normal roll, and the conversation changed to rollercoaster whoops and hollers amid estimates of how high that rogue wave had been. It was not until we were safely on shore that I learned that the strapping on a full set of new kitchen cabinets had broken and that all the cabinets had been jettisoned from the car deck and lost at sea.

Mal de Mare is inherited by many and is a condition that may be inherited with an island escape.

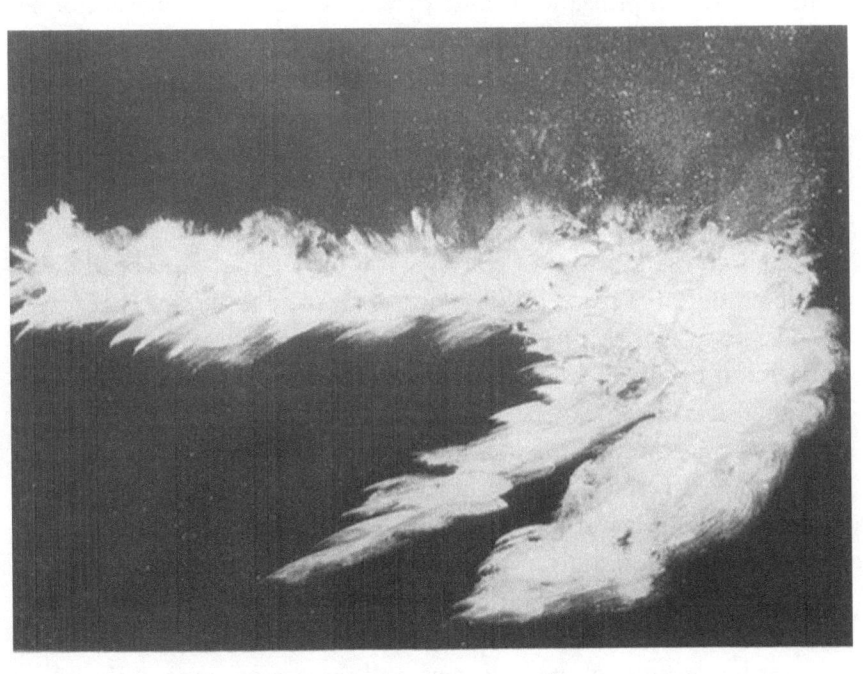

Entitled *Rogue Wave,* this thirty-by-forty-inch acrylic painting is heavy-body acrylic titanium white on black gesso on 150-pound watercolor paper.

## At Sea

The words "at sea" resonate in different ways for different reasons. Comments relate to what an individual body can tolerate. When daylight diminishes, trips back from the mainland to a cold, dark house can be unpleasant. Winds driving waves that you cannot see experienced in a hot, smelly ferry cabin … well, you get the idea.

An enjoyable vacation on a laid-back beach is worth braving a bit of nausea. To do it on a regular yearly basis requires a different approach if you, like most people, are susceptible to mal de mare.

On the other hand, the winter boat is a clubhouse of friends all experiencing the same motion. To live with the negative effects of sea motion is an island badge of courage. It is okay to put your head down or stretch out on a seat until it is over. It is okay to be sick, because it is understood that this has happened before and that you will survive. Ginger and Bonine help. Islanders learn to cope.

Janet has also learned which weather conditions cause what problems. She knows if the waves will push or roll the boat. If the wind is from the east, she knows to beware. If the wind is left over from a winter storm, she is wary of the swells. And to some extent, she predicts the boat's action on a given day and does not fear the unknown. She also understands the shape and stability of the boat and does not fear a roll over or a nosedive. With an understanding of the nature of the ride, she has less fear of the unknown and can concentrate on abundant sociability, which can make the time go in a flash. When she has arrived, her feeling of accomplishment is prideful. The arrival feeling is similar to an ocean liner arriving at the pier.

When it is light and reasonably warm or even a little bit cold, Janet and I like to ride on the top deck in the open air and look for our island or contemplate a day on the mainland or an upcoming trip.

# Freight

Most everything on the island has to come by boat, and in fact the rules are that if you can carry it on it rides free. Bags of groceries, cans of paint, lengths of lumber, furniture, and anything you can think of are carried on and off the boat and into the car and out of the car and into the house, sometimes in the freezing cold. The ferry will take your stuff in a four-by-four box and put it on and off with a forklift for seven dollars, but most people carry. After all, seven dollars is seven dollars.

Food on the island is expensive, not always available, and not always fresh, so you either buy it in America, as we call it, or you can order it on the Internet from Stop and Shop, and they will send it on the ferry in two-by-four green boxes with dry ice when necessary. It costs two dollars a box for a ferry ride of food, but price wise you are still approximately 20 percent ahead going this route. But you have to meet the boat, get your green boxes, cut them open, load them up, take them home, and unload again before things spoil. Most islanders have some form of truck or SUV to handle freight. Likewise most islanders have shopping carts with rollers that roll on the boat and are blocked with rubber stoppers so they don't travel about while at sea.

The mail comes by ferry and is processed in the exceptionally friendly and efficient post office staffed by islanders who know they are operating an important lifeline. Many packages arrive via UPS and must be delivered by truck to the house. Since there are no street addresses on the island, we make them up using a house fire number. We live on a dirt road that has no name, so we made up a name, and the delivery people find us. Sometimes they'll stop to chat, and most always they bring the dog a treat (to keep it, I think, from jumping into their truck or onto them).

Dogs ride free on the ferry but are not allowed to sit in the seats, although they regularly break this rule. Many islanders have dogs and take them to America on the ferry. Each dog carves out his or her space on the boat. Territorial warfare can breakout especially under the seats as the dogs discover one other.

Riding the ferry can be a love-hate experience and takes resilience. After all, you have to ride the ferry or the plane to get back and forth to Block Island or America.

*Ted Merritt*

# The Plane

When we were still cottagers and commuting, one particular weekend ended with a storm. The purple flag was hoisted, but the plane continued to fly. Island planes can fly in strong winds as long as they can see where they are going. Don't worry—the pilots usually carry a hundred-dollar handheld GPS just in case the fog rolls in.

The planes are ancient, eight-passenger carriers with new paint jobs and old interiors. The price, forty dollars one way, has remained the same for many years. The fuselages on these planes leak, and during the first flight out in the morning after a rain storm, passengers will likely get an interior shower from the water-laden overhead padding.

On that particular purple-flag day, it was with all of the above in mind that Janet was reluctant to fly to America where, at that time, we still had a house. But after making her decision not to fly, she consulted her resilience and arrived in the living room to announce in tears, "If we're all going to die, I'm going to die with you. I'm ready to fly." She has been flying ever since, although she is known to close her eyes during the ten-minute flight.

This ancient plane, making a sound like an old washing machine, is part of the island escape picture. It has so far avoided mothballs and is a fixture in island culture.

## Chapter 3
# WILDLIFE ESCAPISM

Behind our house, there is a pond that has another island, which floats around willy-nilly. Our pond covers about eight acres and is surrounded by marsh grass, ferns, small trees, and—you guessed it—poison ivy. It's three feet deep on the edges and increases to thirteen feet in the middle and is kind of a secret pond. This body of water was created when islanders dammed up an old peat bog after they stopped using peat as a heat source. But the peat, an amalgam of decayed vegetation, still remains and colors the water a deep tea shade. Our pond has a gooey, muddy bottom.

    A handful of families live on its shores. We boat, swim, fish, and in the winter when it is frozen over we ice skate. There is no public access. Its many largemouth bass and perch like the environment and hide under the water lilies at the pond's edge. They cannot resist plastic worms dropped from the pads or a spinner with fluorescent orange slash marks. We throw the fish back, even the big ones, because they taste like gooey mud.

    The floating island was born when the peat bog bed was flooded, and the mass of roots and plants sort of popped to the top of the pond. The base of this floating aberration is firm enough to support human feet, but unless one is set on catching poison ivy, exploring the island does not make sense. Wildlife use it as a sanctuary of sorts, particularly the geese.

    Our geese stay all year and use the pond as home base. They fly out daily to forage in the fields and return at night to make music and love. The floating island for them is considered prime nesting territory. The mother goose will take up residence and sit on the egg, and the father

will stake out territory in the adjacent water and act as the guard ... he'll see to it that no other male comes near his mate.

Except for an occasional fight between the males as they defend their slice of water and their mate, all is peaceful. Nobody messes with the mom, except possibly me in my kayak as I swing by to have a look. Interestingly, the island sometimes runs aground and becomes stationary.

The stable situation can last for a month or a day, depending on the depth of water and the direction and strength of the wind. Given good rain and a wind shift, the island, spinning clockwise, becomes mobile and sets off for a new home. As with most things, when the escape voyage will start is unpredictable.

When the island starts its spinning journey, the male goose guards become confused as their landmarks change and their sweethearts disappear from view. I suppose the females also have consternation, but they remain on their eggs. Eventually goslings appear but not necessarily in the planned spot. Because of the nature of the new locations, the task of escorting the goslings hither and yon while foraging for food can become dangerous and scary. But a goose has to do what it has to do, and off they go.

Of no harm to the geese, beautiful painted turtles dot the shoreline, but the pond is also home to snapping turtles that have powerful mandibles and can wipe out a tasty gosling in a blink. They act like terrorists.

So, believe it or not, the geese get together. The same dads that were recently fighting over territory join forces and create a flotilla. In a sense, the geese circle the wagons with the goslings in the middle and the geese, both mothers and fathers, on the flanks and in the lead or follow-up positions. It is not uncommon to see eight or nine geese on the perimeter and thirty or so little ones in the middle. The turtles still manage to get a few from the flotilla, but soon the goslings become large enough to exist without threat of submarine attack.

Mallard ducks also live in abundance on the pond year-round and have the same problems and react the same way. The gull visitors to the pond are smarter. They raise their young in a faraway rookery, which has its own sentinels and seems much safer. They come to our pond to take a bath, rest, fly in the thermals, and generally enjoy the relative calmness of pond privacy.

In the winter when sea winds buffet the rookery, the gulls come to the pond in large numbers to join the geese and the ducks to sleep, drink, and bathe. One winter we had eighty gulls, seventy mallards, and eighty or so geese settled in and sleeping on the ice in their own colonies around a waterhole that they had beaten through. They bathed and drank together and then trudged home to their icy beds.

The ice around the water hole turned yellow, and those about to die wandered off to do it alone. Was the choice to leave the flock an intuitive act of courage and sort of a cultural escape? The ring of yellow urine was a sort of life ring indicating that the birds' bodies were still functioning. The very farthest ring of ice, where three or four birds had died, was sort of like the farthest ring in our solar system, a ring of ice with no life.

The geese have clear pairs, but the ducks seem much more promiscuous. In fact, the bird book says that mallard ducks are quite indiscriminate, having sex on a sort of a willy-nilly basis. The outcome mirrors human society, which has produced a wide range of color and shape blends. Our mallards are white with brown spots, white with green necks, light tan with white streaks, and any other combination that you can imagine. They seem to love each other, but when they die, they do it alone.

Among the redwing blackbirds, blue jays, starlings, finches, cardinals, chickadees, woodpeckers, warblers, and a host of sparrows and mourning doves making the pond shores their home, there also lives a harrier hawk family. With regularity, and I guess as hunger dictates, a hawk, white tail band flashing, will arrive at high speed and pluck a dove willy-nilly from under the feeder.

As we look out on all this, the wonder of nature fills our souls, and we are thankful that we decided to escape from the mainland to retire to this beauty. But what did we escape from and what did we escape to? Are we any different from the geese and ducks? Are we living in the same sort of willy-nilly pattern?

## The Environmentalist

The floating island routinely gets in the way of our full pond view. So I decided to take the proverbial island by the horns and chained it to a tree in a location that was favorable to my view. But on the pond's

shore across from our house lives an environmentalist who observed that the island had lost its freedom and sought me out as the culprit. As I confessed to the deed, she admonished me and directed me to undo the chain so the island could have its richly deserved freedom.

So I undid the chain and freed up the mass of roots and poison ivy. The island apparently had a soul of sorts. It occurred to me that I had escaped the rules of the mainland only to come nose to nose with the rules of the island. What had I escaped from, and what had I escaped to? Here I was fifteen miles out into the ocean with a whole new set of rules and a view obscured by a floating island that had a soul.

## Chapter 4
# ESCAPE FROM WHAT TO WHAT?

It is not hard to remember the many times I have used the concept of escape to maintain sanity, create optimism, ward off depression, and to pass the time. On a seemingly mundane level, wishing for a change in the weather many times is a desire to escape the current conditions, change the environment, and change lifestyles. Going from hot to cold and from wet to dry are commonplace escapist change arguments. We forget how oppressive heat can be in the dead cold of winter and vice versa. Rarely are we accepting of the current condition. Frequently, we look to escape from today and look forward to tomorrow.

As we bring up children, we look to escape the terrible twos and move on to the preschool stage, and then we escape the preschool environment and so forth until the children are all grown, and then we continue to try to escape the various adult stages

In the world of work, we look to "get through the day," escaping to the better environment of tomorrow and from one job to another and finally from the world of work to the retirement world. The term "golden years" is often used to describe the hoped-for environment. However, our expectations for the retirement years do not usually factor in the problems of growing old.

Plans to get away and travel are also a form of escape. Somehow, a trip to the Caribbean with its sunning and swimming is the absolute antidote to unexpected problems of retirement and getting old. To sit on the beach, to read, to eat and sleep long hours are all part of many escape concepts.

## A Pragmatic Approach

Rather than wishing on a star, so to speak, a person's capacity and place in time and space should be assessed carefully and dealt with realistically. The theory is that if you could understand the nature of opportunities available and assess how they might meet your individual needs, expectations would become more realistic and escape would be more satisfying.

To peel off the veneer and look below the surface is a good first step. As we sit in front of the TV and computer screens, as we follow religious dogma, and as we listen to retirees exaggerate claims of happiness, the ability to see behind the screen is important. Once a person becomes convinced that there is no absolute escape other than death, the process of staying alive and extracting enjoyment from life becomes easier and perhaps more fulfilling. I suppose fear of the unknown is the main driver to cause one to want to escape.

A good look inside one's head may serve to define, understand, and perhaps reduce fear.

### Fear

A diaphanous cloak

That focuses and masks angst

An intruder that
Lurks and taunts
Unmercifully
Unknowingly
Ungodly

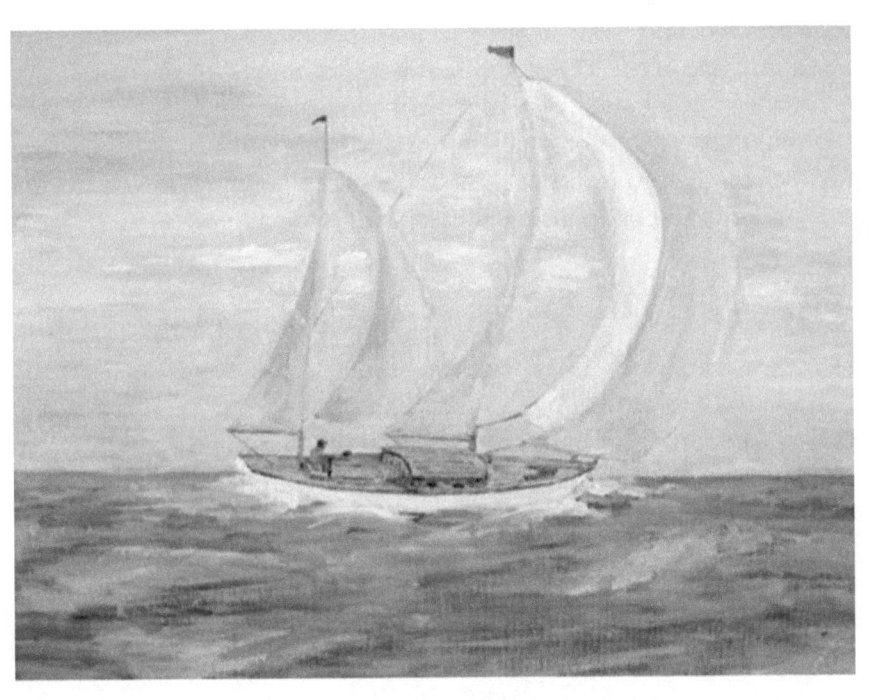

*Block Island Bound* is a twenty-by-sixteen-inch acrylic on canvas of a sailboat headed for Block Island's New Harbor at the tail end of the day. The boat is coming from Martha's Vineyard and is off the north light at buoy B1.

## New Harbor

If you don't move to the island or rent a summer cottage, you can cruise to New Harbor on your boat as a somewhat modified way of escaping the routine world. In the early 1900s, with the assistance of both the state and federal governments, Block Island converted an existing salt pond into one of the largest and best boating harbors in the world. On a Fourth of July holiday weekend, it may host fifteen hundred to two thousand boats. Most boats anchor or tie to a mooring buoy. As a water taxi driver, I got to transport and know many of them. Some plan for and understand boat cruising as escapism; some do not.

## The Water Taxi

Many people are familiar with the Block Island land taxi system, but relatively few are familiar with Block Island's New Harbor water taxi system. At the height of the season, approximately nine drivers representing Old Port Marine Services of Newport, Rhode Island, drive two water taxis from the boat basin and service a harbor full of escapees. The launches carry seventeen passengers and operate from 7:00 a.m. until 1:00 p.m. and sometimes later.

Natural occurrences of wind, rain, fog, and darkness make the job somewhat daunting. Add some inebriated passengers and other pickup complexities, and a driver will often deal with interesting problems.

At seven in the morning, the fishermen are on the dock with their poles and lures, champing at the bit to catch the record breaker. Likewise the dog owners are on their radios, wanting to get ashore before Fido spills his bladder on their teak decks. At noon, the sailors arrive with their picnic baskets and bottles of wine for a romantic sail. Dinnertime brings high-heeled ladies ready for a night on the town with their sunburned captains in tow. As the night progresses, those still sober arrive to be delivered to their waterborne cradles, while those still drinking arrive much later and sometimes require assistance. On

occasion, they fall in the water with their wallets and cell phones. Riders forget sunglasses, radios, jackets, leftover dinners, and sometimes their pets. And yet most seem happy!

## The Water Taxi Ride

On a good day, the weather is perfect, and the passengers are in one of the best harbors in the world and anxious to enjoy the island. They summon the launch by radio. They load surfboards, bikes, beach chairs, beer, big dogs, little dogs, and the inevitable skateboards for the ride to and from shore. Passengers forget their wallets, cameras, suntan lotion, sunglasses, and towels, which necessitate a back-and-forth routine. On a bad day, the wind is whistling, the boats are dancing, the rain is coming down, and passengers, experiencing cabin fever, are anxious to get ashore. Some yacht captains and crew have been up all night watching dragging anchors, and some have been up all night socializing.

## The Pickup

For whatever reason, many passengers are afraid to leave their vessels and board the launch. Many feel that a timed leap is appropriate, and it is at this point that things can get both interesting and dangerous. The launch may approach a vessel upwind or downwind depending on circumstances but always with the driver side of the launch next to the moored vessel. The driver has a short piece of line ready to tie the launch to the moored boat prior to boarding.

As the launch approaches a vessel, a sort of mating dance begins. The launch is the aggressor and attempts to catch the moored vessel. The wind senses the excitement of the ritual and tries to mess up the process. At some point, the two boats decide to cooperate, and the launch driver attaches the line and things settle down. But until this point is reached, an angry patch of water between boats prevents most jumpers from escaping.

## Communication

On a busy day with a crowded harbor and sometimes only one launch running, radio communication gets extremely busy. For instance, a

call will come from the yacht *North Star* wanting a pickup. A short interchange about the type of vessel and location usually follows between the launch driver and the captain wanting a pickup. Information that *North Star* is a white sailboat with a blue sail cover and an American flag is not very helpful, because most sailboats have blue sail covers and American flags.

Location information also gets mixed up. New Harbor currently has a large gray tugboat permanently anchored in the northeast quarter of the harbor, and we use it as a landmark. But a surprising number of people cannot figure out whether they are east or west of the tug or, for that matter, whether they are on the east side or west side of the harbor.

Mooring balls are numbered from 1 to 400, but moorings are not in exact sequence. When it blows, the number is likely to be submerged and difficult to see. Fog, rain, and nightfall add to the visibility challenges. Nevertheless, average boaters assume that once the number is given their location has been understood.

But there are numerous clues that can be helpful including whistling, waving, and shouting. Eventually, they are found.

While talking on the radio, the driver continues to maneuver the boat. To maneuver means to watch out for youngsters in high-speed rubber boats or dinghies, wind surfers, kayakers, recreational sailors, anchor lines, and swimmers. At 5:00 p.m., it is not uncommon to turn a corner and encounter an in-the-water cocktail party or a parade of inflatable dragons, bananas, or floating lounges.

## Amenities

The island offers very few amenities in the harbor. There are no public bathrooms or showers. Nobody collects garbage. With the exception of a small boat that has sold pastries and coffee for the last fifty years, there is no vending on the water. Is the escape to New Harbor worth it?

## Old Harbor

Old Harbor is no better. The ferry arrives in Block Island's Old Harbor, and charter and fishing boats operate from a commercial dock. Much smaller than New Harbor, this harbor might cater to three hundred boats on a Fourth of July. Located near the front door of most of the

island's shops and several bars and restaurants, this harbor can get noisy. It does have public showers, but it does not have a water taxi.

## Anchoring

A Block Island summer afternoon usually sports a New Harbor breeze of fifteen or so knots and is amazingly cool. The water is clean and very swimmable. Boats come from all over the world to New Harbor to use it as a fishing or racing base or to just plain kick back and escape.

Given the wind, space, and relatively deep water, the harbor has become a sailing mecca. Day sailors, cruisers, and racers sail in and out of the narrow inlet. It is not uncommon for an eighty-foot sailboat to come all the way in under sail and poke about a bit before lowering sail and mooring.

Given the scenario outlined above and given the thesis that most boaters are trying to escape, it is questionable whether the experience measures up to expectations. But boaters seem happy and determined to validate their chosen method of escape.

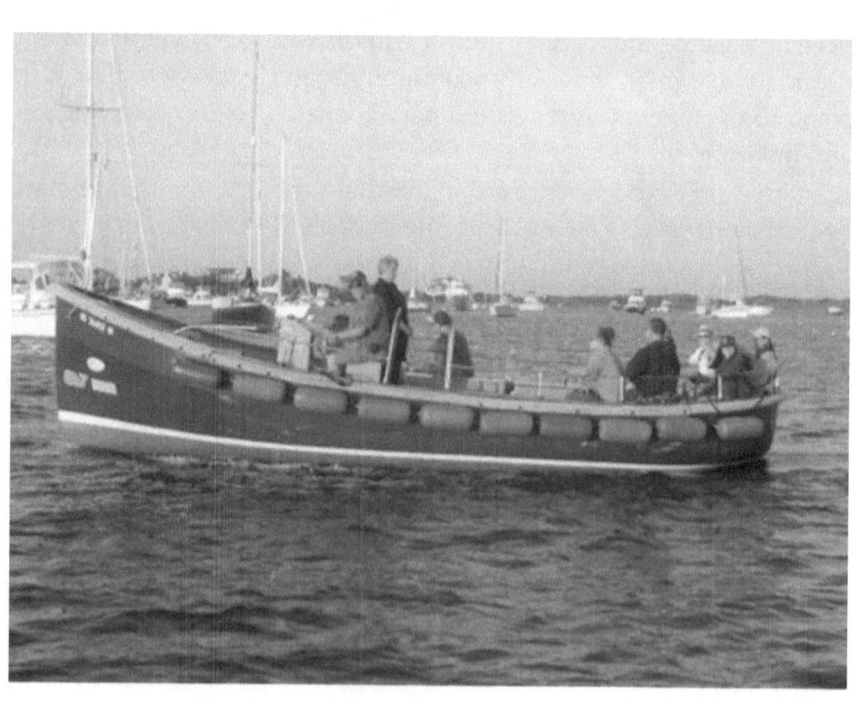

This is a photo of me driving the water taxi and doing a photo cruise for the Spring Street Art Gallery. On the trip, we seek out scenic spots and follow the lead of Grace Luddy, a gallery photographer.

## Chapter 5
# RELIGIOUS ESCAPE

Many people, I am sure, use the church pew to attempt an escape from whatever for a moment and, more importantly, to insure a quality grand escape when death arrives. Jan and I attend with some regularity both the Jewish and Episcopal services on the island. Jan is Jewish, and I was born a Protestant. Like Jan, I can fit in anywhere.

We both respect the complexity of life and the mystery of our creation. We believe that man is innately good as opposed to evil and are agnostically inclined. We are happy to go to any church and try to get along with everyone.

Given our liberal notions on the nature of God and the lack of a need for ritualistic activity to achieve status in heaven, you might wonder how we can see our way clear to participate in the local dogma at two different congregations.

In spite of the fact that I like the sensual aspect of living, I question whether the concomitant pain is worth it. I like to eat and sleep and smell and touch. The colors of the world are stimulating, and the various permutations of living are intriguing. But if you believe, as do I, that immortality is what you leave behind and that death is the absolute end, then why is it worth staying alive?

I guess the worth of life under my thesis would be the balance of pleasure against the balance of pain in a simple algebraic equation. I continue to wrestle with my own artist son's suicide in his thirties. The average observer would say, "Why did he do that?" But there are others who would break with convention and applaud his courage. David's thought patterns, as a schizophrenic, gave him considerable pain. He thought that he gave others pain. I don't think he hanged himself to

end the pain; rather, I think he hanged himself to end the process of paining others. We both accept his suicide as part of the mystery, and we treasure his acrylic art as a fond memory.

My mother, a bright and gregarious personality until the end at ninety-five, offered the suggestion that she was considering taking her life because life was getting painful, partly because she felt she was becoming a burden. She had no compunctions about sharing these thoughts, and when I raised questions about the appropriateness of such an act, she quickly pointed out that many of her fellow nursing home residents felt the same way and were in the process of carrying out controlled suicides by starvation.

## Our Local Congregations

Let's take our synagogue congregation first. To appreciate my thoughts sitting next to Jan, reading aloud and individually the service in Hebrew, you must understand that I have been welcomed into that congregation. In fact, I am a member because the House of Ruth, the island's Jewish institution, has a rule that the spouse of a Jew can belong, participate, and even vote at congregation meetings, which I do. The House of Ruth's philosophy is unusual but very fitting for our small island. The congregation feels that everyone on the island simply must get along together. General welfare and sometimes out and out survival require that religious dogma not get in the way. So I have learned a bit of Hebrew and chant and sing with gusto.

The Jewish services are very warm and family oriented. Children walk around during the rituals, and mothers and fathers do likewise. Everybody smiles. On the other hand, we have two erstwhile cantors. Both are lawyers who have differing interpretations on various points of religious appropriateness. They go at each other with some regularity, and the congregation gets annoyed.

Some of our close friends are members of the Episcopal Church. They have welcomed us warmly. In this case, they have their own building and priest. Father Dan is also a friend, a fellow boater, and is a laid-back, good guy. When asked about his feelings on our attendance at his church, he encouraged us to attend. He imposed no rules.

So we have gone now and then to the Episcopal Church and enjoy the warm, sunlit, song-filled, and caring membership. Once a month

the church has a potluck supper in a private home where the food is good and again the atmosphere welcoming. Members from other churches come to the potluck including Catholics, Baptists, and others.

As we follow our church journeys, we both know enough to be careful what we say. We have learned to stay away from philosophic dinner-party discussions and to turn conversations around to find out what the other person is doing or thinking.

One couple in the Saint Ann's congregation lost their son to suicide at about the same time we lost our son. The couple reached out to help us, and we did likewise, and there is a resultant bond of friendship that will probably last forever.

In a sense, we have escaped from the mainland's sense of religious propriety and strict interpretation of rules and regulations. We are in an island environment where the general welfare of all and the need for ecumenical considerations have made life much easier and more comfortable. Our private thoughts are our own business and are very much respected. Our presence in the congregations is appreciated.

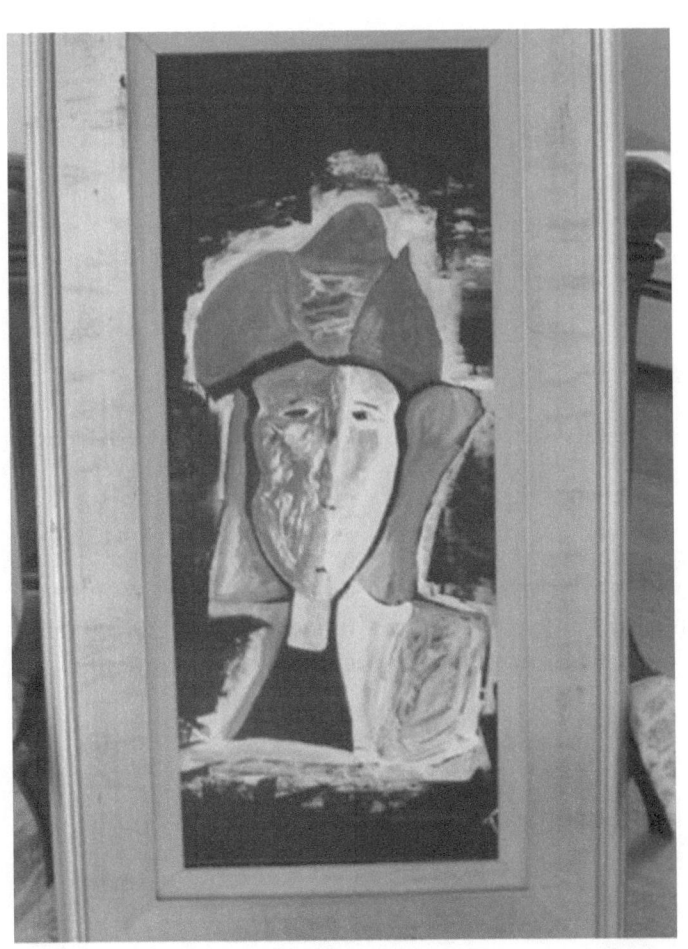

Ted Merritt

This twenty-four-by-ten-inch acrylic on Masonite is entitled *Lady of the Cloth*. This lady encourages ecumenical activities as you can tell by her quixotic smile.

Chapter 6
# ESCAPISM IN BUSINESS AND CULTURE

While the churches and religious groups serve as social hubs, the real circles of influence revolve primarily about money. The island's influential leaders work hard to keep the economic engine going. Business leaders band together and figure how to extract as much money as possible from island visitors. They take advantage of the escapee tourists, and then they leave the island and go to someplace warm to do their own escaping during the winter.

Island business focuses on lodging, food, and entertainment. Bicycle and moped rentals abound as do art galleries. With the exception of a new small weaving business, no other manufacturing exists.

## Circles of Influence

It was interesting to read a 2008 Penguin book by Sudhir Venkatesh entitled *Gang Leader for a Day* in which Sudhir, an Indian sociologist, writes about the drug dealer circles of influence in Chicago gangs. He draws a fine line in his description of their function as part welfare and part criminality. In other words, the gang takes care of and protects the residents, and the police basically look the other way. In some of his descriptions, the gang leaders are made to appear altruistic, caring, and generally likeable. He paints the population he is studying as up against almost insurmountable odds and doing the best it can to survive.

To some extent, the Chicago experience reminds me of Golding's book *Lord of the Flies* where boys on an island are left to their own

devices. A sort of survival-of-the-fittest governance system evolves. In both books, survival and greed mixed with lust are the life drivers. Governance by the elected according to the rules has little effect.

To some extent, the same environment exists on Block Island. The summer economic engine must run well if the island's year-round population is to survive. The business leaders are the island saviors. Because Block Island is isolated at sea, many of the rules you would expect to see in a modern society are absent. The elected leaders and the appointed committee structure that supports them have very little clout.

While the elected leaders act as if they sit on top of the mountain, it is really several spheres of influence that govern the island. First and foremost are the business leaders with their own informal communication and management structures. The breakfast group meets daily to digest information and create rumors. The group reaches out in a behind-the-scenes way to influence appointments, shape rules and regulations, and grease the economic wheels that drive the island. Connected in an odd sort of way are most of the large hotel, restaurant, and store managers.

Likewise there is a harbor club. Its members live on the dock in the summer and pass judgment on harbor management issues. Most club members make good incomes from their relationships. For instance, when it blows and boats break loose, the club divides the spoils in terms of repair, towing, and general salvage fees. Very much like the Chicago gangs, the club decides which rules are enforced and which are not.

The State of Rhode Island, known to be corrupt, also has its hand out with a wide array of permitting and control procedures. The state controls the water and approves any use modifications. Occasionally the island has to buck the state as illustrated in a recently contested marina expansion, which was not acceptable to any of the island's local spheres of influence. So island leaders banded together to fight using every bit of their formal and informal strength.

A Wild West mentality still exists on the island. When a powerful excavator was told to shut down his gravel pit, tires were slashed and threats were made.

## Culture

If you want to escape the mainland culture wars and think that living on a small island fifteen miles out at sea will reduce that type of conflict,

you are right and you are wrong. On a winter day, you will encounter a wave from almost every driver and receive a hello from everyone. You will think, *This is a friendly place.* If you transfer the thought process, you may likely draw the conclusion that people on the island have become culturally neutral and that therefore being on island is the best of all worlds. Upon reflection, however, you will be quick to remind yourself that it is not easy to change cultural bias. Moving to a small island does not automatically change deep-rooted cultural bias.

## A Block Island Culture

To some extent, once you are an island resident, a new culture is superimposed on your old one. Let's call it a culture of resilience. Much as if you were adrift in a lifeboat, the need to survive on that island is the controlling factor. On the lifeboat, you would not spend time shunning someone of another religion; you would not be concerned about your dress; you wouldn't be fussy and selective about eating habits; and for the most part you would make working with the lifeboat's passengers a top priority. Similarly, on Block Island, you help the sick, hungry, and generally needy with the hope that if you find yourself in a similar circumstance, a return of help will be there. On the ferry, you put up with fellow passengers, a noisy dog, or an upset baby. You make your seat available if necessary. But you don't necessarily change your inbred cultural feelings.

## The Island's Counterculture

Down deep and behind closed doors, typical culture differences come into play. The Baptists support the Baptists; the Catholics develop their own society; and the Jews socialize and support each other together much as on the mainland. The Italians do their thing, and the Irish do their thing. The only difference is that cultural bias is not shown openly.

To complicate matters, the island has established many committees to advise and lead. Unfortunately, of the thousand or so winter residents, not many are trained leaders, and not enough have the management skills required to produce a good committee product. Issues are beaten to death, and in many cases, progress is nullified by the process. "Why change?" they ask. In fact, island progress has been made primarily

by doing nothing. This could be called default thinking. As a result, the island's natural beauty has remained generally unspoiled, because development and associated changes haven't been approved.

When asked about values associated with island living, the general response is that islanders live to make money in the summer to be spent in the winter. If you were to suggest that the island should stand for ecological integrity, ecumenical existence, and family-bred hospitality, you would get a weak "yeah, I guess so" response. And if you were to push the matter and suggest that tourists need more bathrooms, for instance, you would get a "yes, I guess so, but we can't afford it right now" response.

The club you belong to and the restaurant you eat at are just not social issues. There are no formal clubs, and most times only one or two restaurants are open in the winter. How you dress is also not an issue. Island dress is of all styles and generally universal and similar. In the winter, it is jeans and warm coats that are resistant to weather and dirt. (Many roads are dirt; most houses are garageless, and many vehicles carry dogs—mostly big, sandy, and slobbery).

So you really don't get a look at culture on the island from a surface point of view. While the uninitiated person figures that island life has resolved its differences, he is, in most cases, wrong. But if you are looking to escape dress and other social codes, Block Island may be the place for you.

You will, however, have to learn a new set of escape rules.

## Chapter 7
# THE ESCAPEE (ME)

As we examine the act of escaping, it becomes important to get to know the nature of the escapee. Since what I am presenting is, for the most part, autobiographical, it becomes important to get to know me with the assumption that you and I are more alike than not and that my capacities and abilities to escape might be of interest. Also, the thesis of this work is that a true escape is an inward adventure and not a move from one place to another—unless of course the move somehow satisfies one's inner needs.

### Physical Capacity and Ability

The medical profession is making major progress in unraveling the management systems that make us tick. And it is not difficult to buy into the evolution theories that explain the development of the human body from a cell to a man, and it is not difficult to see the relationship of man to animals and even plants. It is not difficult to assume that upon death the body becomes inanimate dust and joins the other inanimate dust on the planet. It is not difficult to imagine the earth as a speck in the universe of specks. What we are not good at is figuring how and why we were created. We use the terms *prime mover* and *ultimate power* with regularity, and it is not difficult to imagine that there is a reasonable, logical explanation describing such a prime mover. Call the prime mover God if you will. Having accepted all of the above, problems associated with living in your own body are associated with the short term of its existence. The elements of surprise and fear when things go wrong are still a big problem.

## Dealing with the Body

Many people develop a faith and belief in an afterlife, which is comforting when one considers the relatively short time that the body will function.

It is not popular to assume that when death occurs everything stops. I consider at least a portion of immortality to be leaving things behind, such as memoirs and artifacts. Wouldn't it be interesting if we were able to transfer the brain to another body with all of its contents … brains would be full of amazing things!

Current body freezing techniques are interesting. It would be interesting to have my brain frozen for later use. Much as we download our computers to a hard drive or a smart stick, my head can be downloaded and saved at least in terms of what it knows.

While this cannot be done in absolute terms, I suspect that we are not more than a few decades away from such an occurrence. I am particularly interested in the concept of transporting people hither and yon by beaming up molecules and sending them somewhere wirelessly. It is my understanding that companies like IBM are well down the road on this type of technological breakthrough. How long it will take them to save my brain in a digital fashion and transport my body and brain in a similar fashion is hard to fathom.

Whoever suspected that the Internet would come to be? In similar fashion, who suspects that we may be able download a brain and transport a body wirelessly? I like to think that all of this is possible but am sure that it will not be in my lifetime.

I and my brain are expendable and will, I think, be even more expendable in the future. Already we are wrestling with the expendability of people and their bodies because they are worthless from a scientific point of view. Whoever is first out of the gate with the power to create people will win control of the earth and adjust the production of bodies so we get only as many as we need. It is assumed that the new bodies will then have the genetic capacities desired.

This assumption raises huge questions about the viability of democratic government as we know it and the importance of absolute power perhaps related to nuclear, cyber, and biological warfare. I suspect that the United States' leadership is fully capable of contemplating the dimensions of these types of problems, but I am not sure that our

government is capable of implementing a plan for dealing with related issues.

So where does this leave me and my body? In simple terms, nowhere! I will die, and that will be it. It would be fun to contemplate escaping into another body, but I suspect that that possibility is decades into the future.

## The General Welfare of Mankind

I am trying to take care of others so that when I can no longer take care of myself, they will take care of me.

However, it would be much easier and less painful to take my life when the time comes, but the system does not allow for that. To balance pain and pleasure in my own head, it seems to be important to stick around until so-called natural causes kill me.

Someday I am sure that will change. Much as we do with a pet that is hurting, a person will be put to rest when the pain becomes too great. We, of course, do some of that that now, mostly behind the scenes with morphine as the main killer, but we wait so long. We seem to be unwilling to look down the road and provide an early out. However, this seems to be changing as the pressures of expensive care for the terminally ill dictate. As the Medicare system becomes smarter, assisted deaths will become more frequent and more economical. Likewise births will be controlled.

At the moment, we are enabling more births with techniques like in vitro fertilization. By blending genetics in a logical way, we will be able to develop higher quality individuals. By controlling births in terms of the number of children allowed as is done in many countries, we can also control the population. The real question is which governmental system can best meet the needs of the world with a birth-through-death design.

## Temporality and Emotionality

The golden years of retirement are balanced on a seesaw of temporality and emotionality. On one hand is the knowledge that your physical body is on a downhill slide, and on the other is the pleasure of enjoying what is good before it is gone.

My morning walks with our dog Sondi are times for contemplation, validation, and general assessment.

To some extent, the walks are a mental escape. Sondi joined us on the island at eight weeks of age and has since developed an extensive social life with fellow dogs and loving people. She looks like a Portuguese water dog but in fact is a combination golden retriever and standard poodle that turned out jet black. She is therefore a golden doodle that exhibits retriever qualities, doesn't shed, and likes the water. Talking with her eyes, ears, and tail, she helps me solve many problems on our long walks.

I don't run anymore, because a sports physician showed me a picture of my knees and taught me about arthritis. Since then I have understood my multiple aches and pains with particular reference to knees and hips. After a good walk, I can feel both hips speak out. So in general terms, I am pill free and in relatively good shape for my age. I am not overweight but with regularity I am depressed.

When living gets painful, I am reminded that my insurance policy does not recognize suicide as a payable form of death. I am also reminded that Janet loves me and wants me to stick around. Likewise I am convinced that my family would rather see me alive than dead.

Both Jan and I have our share of professional awards. We have been heavily involved in community service. Our many applauded life accomplishments do not mean a hill of beans as listed on the net and in the immortality register. So what matters?

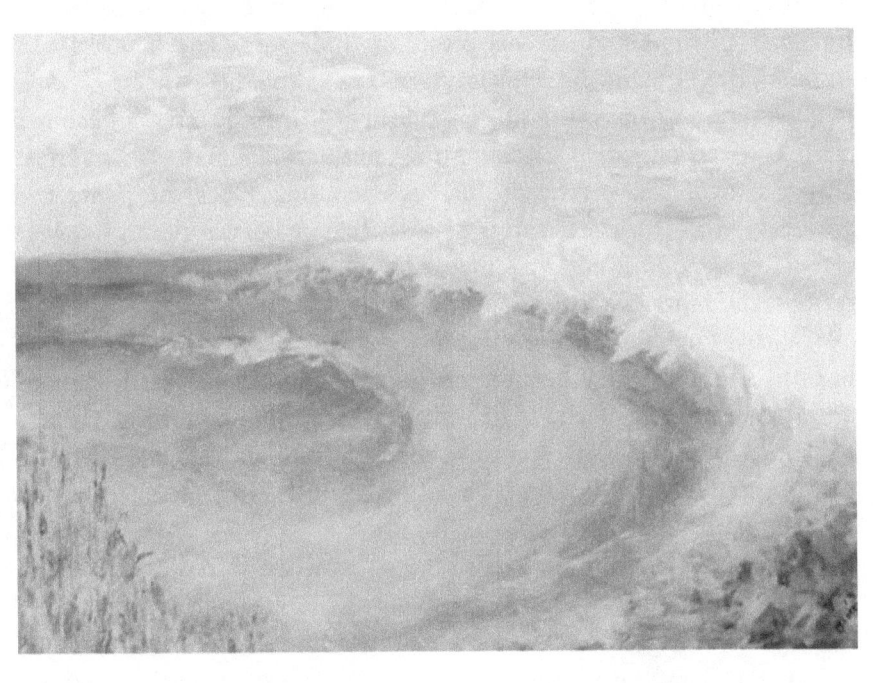

This is a thirty-by-forty-inch liquid acrylic on Yupo paper entitled *Solitude*. It represents the uplifting and private experience one enjoys watching a breaker hit the beach.

## Radiance

James Joyce, in *A Portrait of the Artist as a Young Man*, outlines an aesthetic theory that has been useful to me in measuring what matters. To assess the true nature of beauty, he suggests that you first isolate the item you are trying to assess in your mind in order to establish its *thingness*. Then he suggests that you try to understand how it works—its functionality, if you will. This is referred to in the theory as its *rhythm*.

If an item can pass the thingness and erythematic tests, it becomes eligible to be classified as something beautiful. This last and most elusive concept is then ready for consideration. Does the item have radiance? And if it does, can it be classified as beautiful and likewise classified as something that matters? The more radiance the thing exudes, the more beautiful the thing is.

With some regularity, I submit myself to this aesthetic test. Am I beautiful? If not, can I become beautiful? Would it be worthwhile to become beautiful? What is beautiful? Declaring something radiant requires an educated judgment and then a leap of faith. In the scientific world, this type of thinking is called heurism. It is an educated hunch that something has radiance.

Obviously, there are high and low aspects of radiance. When referring to a person, it can become very complicated. That is why I have never thought of myself as radiant, and with some regularity I conclude that even if I wanted to I could never become radiant enough to project the required glow of true beauty.

My presence on this earth is a random act. Concepts of predetermination do not make sense. A universal prime-moving power is understandable and in all probability exists. That we here on earth may only be a tiny part of the universe's entire fabric is conceivable but not helpful.

To assume that we must be good because God is good, to me, is silly. To assume that our purpose in being is to do well is also silly. But to recognize that coexistence with others is important can breed a brand of altruism/egoism that is workable and perhaps memorable.

A pragmatic set of human rights exists by necessity. It supports the need of the populace and calls for a general-welfare approach. But support for the general welfare of the populace is not a reason to stick around when you have stopped a related occupation and are in retirement mode. In retirement, if you gave at the office, so to speak, you should have time to probe your own self and examine unexplored qualities in search of personal radiance. Or in other words, you have a right to take care of yourself as the first order of business and to escape.

In this introspective, escapist process I have elected to examine my senses in search of personal radiance. Who am I? What are my capacities? How acute are my senses? How does my brain function? What is stored in my left brain? Is there anything there worth working with or on?

I like it when the grasses ripple in the breeze and the seagulls soar in the thermals. I like it when a silver fish is pulled from the deep. The unpolluted sky of stars and the similar rainbow colors related to the moon and sun are stimulants. I like breathing the salt air. I like the way the desert rolls toward the horizon and the mountains appear much like waves. My sense of color perception, taste, sound, and a wide variety of tactile impulses provide input that is stimulating and at times radiant.

To reflect on this ultimate radiance, I try to sing and paint, looking for relationships in sound, color, and form that speak out and define myself. It is interesting, though, to find the musical worms in my head expressing themselves as I paint the patterns of the waves breaking on the shore and the shape of the clouds as they introduce a storm.

I recently practiced for a chorale concert that included excepts from *Phantom of the Opera* and found those musical phrases, which I call worms, constantly echoing in my mind as I painted a surf scene. But the going is rough. I am inept. I do not yet know what it is that I am looking for.

Relationships of brown, violet, and green speak out to me. High, well-rounded sounds and, similarly, low, well-rounded sounds likewise speak out. I have learned to produce color resonance on canvas and in my own singing voice. I wonder how many people experience this sensation. I am not aware of any data that reports on how intensely people see and feel color and sound. Likewise, no data exists to my knowledge on the feeling that various combinations of sensual experiences evoke.

The color of turquoise under the break of a wave and the cacophonous roar of water that concludes in an explosion are significant. The wave breaker experience is closely akin to the feeling of reaching a full-blown high or low note with my voice. I suspect that many others have the same enjoyable experience. With the island choir, at times we blend notes and make musical statements that approach radiance. The violin of Heifetz, the voice of Pavarotti, and the taste of food often qualify as radiant experiences.

Watching Haitians dig out from a monster earthquake gives me pain and makes me cry inside. Tragedies like the Haitian one and more recently the Japanese and Philippine storms support my willy-nilly theories about the lack of reason in human existence. The prime moving source is neither an altruist nor an egoist. There is no pattern. Stuff happens willy-nilly. Does the abundance of pleasure in life outweigh the abundance of pain? How will the balance change as I get older?

I suspect that the balance of pain versus pleasure in my being is tipped toward pleasure much more than in most people. And if I, in my privileged environment, consider life at times overbearingly painful, what must be going on in other people's minds? But many folk are supported by the ancient and conventional wisdom that calls for forbearance. All will be redeemed in heaven or something like that.

If we were able to educate people to understand the facts of existence and took their crutches of faith away, some people would get a much better look at the human predicament. I suspect many, if they could, in this new state of awareness, would decide to depart. The Muslim suicide bomber has done just that. He has gotten permission to depart with dignity and with false promise.

Euthanasia, as permission to go, will become, in my opinion, more popular and more legal as the time machine spends more time revealing the lack of reason for our existence. At some time, "just because" will become a much more reasonable answer and will make permission to go with a similar rationale more feasible.

It should and will become much easier to say good-bye properly once the rules are overturned.

But a concerted effort to get to know oneself on the inside and better enjoy and meet internal needs may enable a pleasurable escape from some of the pain. This process may logically prolong life.

## The Scale

Much like the scales of justice, I use a scale to weigh pain on the left and pleasure on the right. I include in the measurement some sense of how long the pain and pleasure might be likely to last. For example, one winter morning, a heavy rain had just finished removing all the snow from our island, and a winter wind of significant force was blow-drying the puddles. The ferry captain canceled the first two boats, but the planes were flying. We were not totally stranded.

It was Martin Luther King's birthday, so things in general were shut down. A combination of the weather and the holiday had cleared the roads, but I appeared to be the only one out and about. I was dressed properly with warm boots, a jacket that was not too hot or cold. Sondi appeared to be ready to walk, so we set off on a four-mile tour of barren trees; sullen, wind-driven skies; and a glorious array of puddles. The sea, even in the lee of the island, was studded with whitecaps, and my body, more or less rested, was happy. I was not in a hurry, so I ambled along at my own pace, sharing time with Sondi, an inveterate sniffer. Try as I might, with some depressed impetus, I tried to classify the experience as painful. It was not, and therefore it was pleasurable. We stopped and helped the magnificent east lighthouse look out toward Portugal.

The light was moved back two hundred yards from its eroding cliff to save it from a crumbling death. Its beacon still warns worldwide travelers looking for a first glimpse of American soil. Directly west from Portugal, the light watches whales, tankers, solo sailors, and migrating birds, all busy exercising the art of survival and escape.

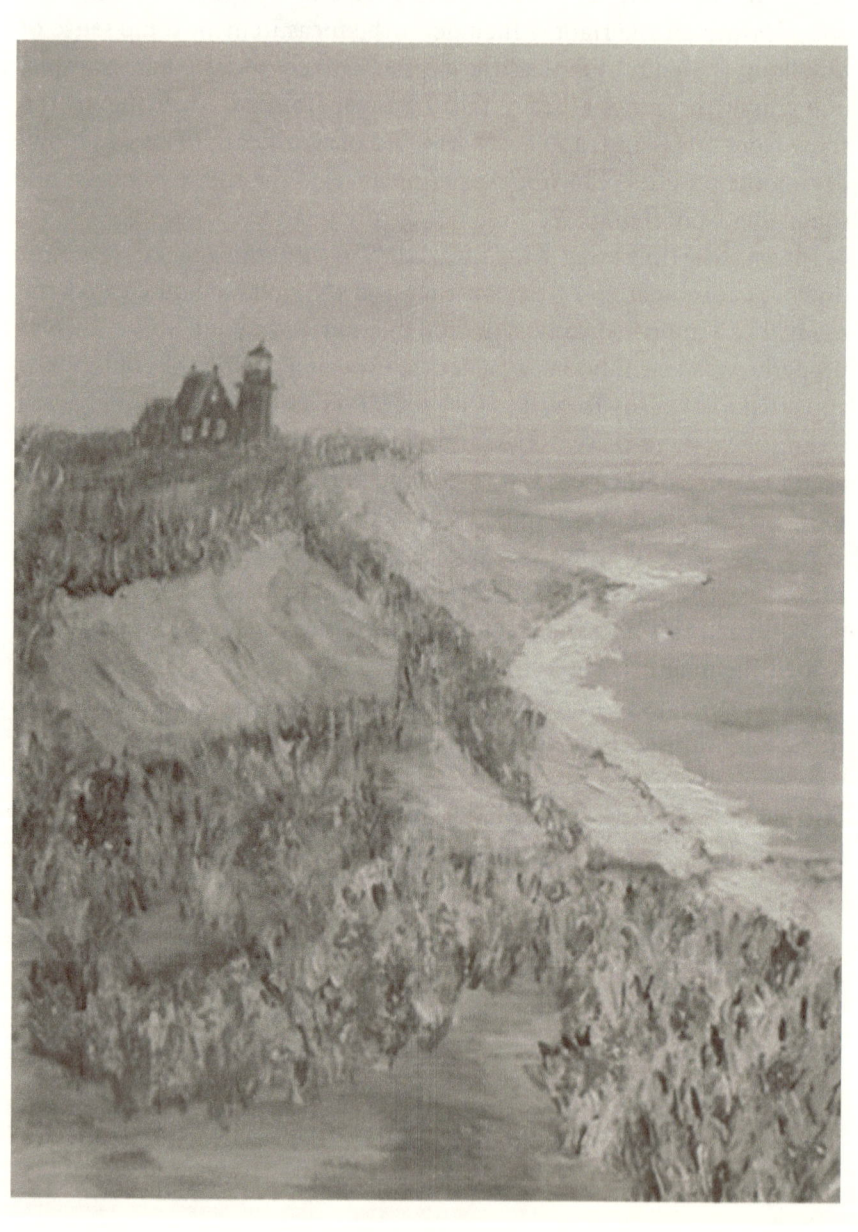

This thirty-by-twenty-inch acrylic painting on canvas is of the southeast lighthouse and is entitled *Sentinel*.

I like the idea that I can walk in the morning without seeing a stop sign, a traffic light, a person, or anything else that is likely to impose a rule on my existence. I like the idea that I can return to my house, which is warm and generally watertight with food in the fridge, and to Janet. I really don't want to be anywhere else. I like the idea of being home with my art, music, and writing to contemplate. It is interesting today to be able to think about my existence as more pleasurable than painful. I am a happy escapee.

## Escape from the World of Work

For thirty years, I held the position of public school superintendent in Monroe and Trumbull, Connecticut, and Bethel Park, Pennsylvania. These jobs required a constant attentiveness to the problems of a community school system. My school systems were upscale suburb types with considerable size and affluence. With regularity, I felt as though I was selling my soul to one side or the other to keep the educational process moving.

I traded quantity A to get quantity B. When I proposed making change on the left bank of the river that was sure to upset political machinery, I started a fire on the right bank to divert that attention. If the teachers were pleased about something, the parents inevitably were not. If the custodians got upset, the food service workers mocked them, and I had to solve the problem.

One of my elementary principals had too much to drink and propositioned an eleven-year-old girl in a neighboring town. So I fired him with the support of my board. And you would think that would be that. But no, the principal and his wife were local favorites. He lived right next to the school, and the faculty rose up as a body, saying, "A mistake is a mistake. Let it go. He deserves to keep his job. He won't do it again." The parents weren't so forgiving. Such an action was not appropriate under any circumstances. Nevertheless, the faculty got the termination decision forced into tripartite arbitration. It was the staff against me and the board, and it was ugly.

The board of education and I were supported by the arbitration panel, but somehow the victory fell with a dull thud on my ears.

Why had all of this been necessary? Not until I left that system did I understand that the staff was counting on me to stay strong so they could show allegiance to their principal and friend and a fellow human being. They knew that he should be terminated, but they would not let on until their retirement party for me. It was lavish and caring, and I finally understood that they cared for me too. But three years had passed since the termination. It wasn't always clear that we cared for each other.

In a similar vein, the new football coach wanted to keep his all-state linebacker on the football team even though he had allegedly raped a high-school girl at a party. The linebacker was important to the team, the coach reasoned, and the court had not yet rendered a judgment. Why couldn't he still play? The argument became so heated that the coach threatened to march the football team to my office in protest. Fortunately, a mature athletic director saw my point of view and persuaded the coach that he was wrong. But the coach clearly wanted me to sell my soul for the football team.

Life as a public servant was life as a puppet attached to one string or another. The constituent groups yanked at me in sort of a willy-nilly fashion, one way or another, as the spirit moved them. One board member was elected to be my critic and to diminish my fiscal requests. He wrote an article for the national press accusing me of being a carpenter with a rubber yardstick. He claimed that I couldn't tell it straight if I wanted to, because my sense of measurement was always off to one side or the other, depending on circumstances. Fortunately, I outlasted him.

But the point of the matter is that I never had time to assess. I was seemingly always performing in a wind tunnel. It felt as though I just gut-reacted my way through my vocational life, assuming that the product was more pleasurable than painful. Was it?

I suspect that many people functioning at such a frenzied pace in the working world have the same problem. We did not have time to think. We simply didn't have time to assess what was pain and what was pleasure. We then retired into an escape mode, unsure of what to escape from and where to escape to.

I take pleasure in eating, sleeping, and various kinds of social interaction. I take pleasure in being artistic and appreciating art. Likewise, I take pleasure in music. I also take pleasure in repairing the

house, driving the harbor water taxi, and teaching people how to use boats. I like walking the beach and the roads, watching the birds, and being in touch with the weather, particularly the waves and the sky. I like being with my family.

As my body deteriorates, I may have to give up more outdoor physical activity. As my hearing and voice deteriorate, I may have to give up the music and the creative side of art. Perhaps it will become difficult to communicate with family and friends. All of the deterioration problems will press down the pain side of the scale.

What will I be able to put on the pleasure side?

We have disability insurance that is supposed to pay for a needed caretaker. Perhaps that expenditure of money won't be needed. But what will? Presently I am a very active and physical human being. Will I become a burden to myself and my caretakers without the physical opportunity? Will acquisition of health care become difficult? What if I start to feel the effects of Alzheimer's? Do I have the right to pick up and go without causing real problems for my immediate circle of friends and family?

I ought to have the right to depart, but I don't. That problem adds at this very moment to the pain side of the balance beam. I don't like the fact that I am not in control. I don't like the fact that the rules of society, the medical profession, the religious institutions, the government, and my insurance company all supersede my decision making. I worked hard climbing the prescribed ladder as a child, a student, and a member of the armed services, and I worked hard as an educator and gave to society.

After completing a bachelor's degree at Dartmouth College, I spent two years as an engineer officer on a mine craft support ship in the US Navy. We endured the Cuban crisis and delivered minesweepers to Portugal. But most of all, we worked to keep the old converted three-hundred-foot Landing Ship Tank (LST) functional.

After the naval experience, I started teaching high-school English and completed a master's degree in education at the University of Bridgeport in Connecticut.

I became a state rehabilitation counselor and a special-education director and completed a doctoral degree in educational administration at Teachers College, Columbia University. While I was climbing the administrative ladder, Janet was busy completing her master's and

climbing her own college administrative ladder at the University of Bridgeport.

I escaped into the world of retirement and managed to tip the balance of the scale to the pleasure side. I don't want it to tip back. If I become a taker, a burden, or any other of the many painful concepts that come to mind, I will want to leave neatly and cleanly, making the world and my life better as a result. That is exactly, I think, what my son David did, and his actions were somewhat accepted. But being of sound mind, so to speak, at the moment, my rationale will not be accepted. Dave had schizophrenia, so his balance of pain versus pleasure was acceptably different.

## Another Tool: Music

I have no idea how my musicality relates to that of others, but appreciating music and singing with and before others is a big part of my pleasurable escapist mode. My mother played the piano and insisted that I at least give learning to play a try. So at the very same age when I wanted to be out with my friends exploring and getting to know the neighborhood, I had to get cleaned up and go to Eleanor Lang's house and have lessons. It wasn't much of a pleasure if I had not practiced. So several times each week, I sat down on my own with the John Thompson music book and did my lesson. Part of the experience was fun, because I kind of liked to produce music. Part of it was drudgery, because I clearly had other things on my mind.

Miss Lang used to sit next to me on the piano bench, and with ultimate patience, she would point out my errors, and I would do it again and again. I wanted to kick her, and I think she knew it but we were both too well-mannered to cause trouble.

I eventually graduated to the grade 3 song book. This collection of music had some substance, which allowed me to play in student recitals. I also played for the family at home when show-off time became mandatory. When I retired from the piano in about sixth grade, Miss Lang and I parted ways, but Miss Holroyd, the principal of our public elementary school, picked up the cause. She felt that a band would enhance the school's learning environment, and I was introduced to Mr. Bear and the clarinet. The same learning process ensued, but this time I knew how to read music and advanced at a more rapid pace.

The clarinet, I think, was chosen for me. I never much liked its sound and probably would have been happier with a trumpet, but life was too rapid, and I accepted the reed instrument. I was well-mannered in response to most of my mother's patient but demanding wishes until I reached high school. At that point, the desire to escape family control manifested itself.

In elementary school, Miss Holroyd had a marching band, which all able bodies joined. She marched us through the Bridgeport, Connecticut, neighborhood to the delight of the neighbors. On formal parade days, we wore white shirts and pants. We also sported a captain's hat and a blue banner saying Black Rock School. In those days, the banner was much like a letter sweater, and we wore it with reverence. I can imagine some of the downtown parade viewers mocked us as the elementary school band from the wealthy section of the city. We were the only elementary school in the parade.

All of the high schools had bands, and I was destined to follow that route. I was allowed to have a large gold tenor saxophone that made more noise and was acceptable in the world of girls, football, and cool sounds. However, my behavior during my high-school days was not acceptable to my mother and father. Since I found myself in trouble with regularity, and sometimes with the police, I was removed from public high school and sent away to a residential prep school. While there, I opened my eyes and rapidly adapted. The move happened in the first quarter of my sophomore year.

Berkshire School had a well-developed music program, and I was determined to sing in the glee club, which was accepted by my friends. The clarinet became part of a woodwind quartet, and we traveled in the community, primarily to the churches, to play classical music and market the school. My saxophone stayed in its case and eventually was sold to my mother so I could buy a part for our racing sailboat.

All of the above followed me to Dartmouth College, which had a quality music program. I tried out for the freshman glee club. At my audition, Dr. Zeller asked me to hit an A right out of the air, which I could have done if I could have thought it through. But in the rush of the moment, I could not. In an understanding voice, he asked me to read some music and follow the tones played on the piano with my voice. And shortly afterward, he invited me to sing with the glee club. The experience was enriching, as I learned about the dynamics of music,

how to follow harmony parts, and most of all to listen to some of my classmates who had quality voices.

After college, now in the family mode, I spent spare time with my children, who were athletically oriented. Music took a backseat. However, my daughter Alicyn, who sang and composed, did follow both the musical and athletic routes. I can remember listening to her playing her national-award-winning "Changing Sands" composition for a hotel full of PTA types. She played the piano and sang through her first two years of college; then she dropped out and started waitressing at the music bars in San Francisco.

Unfortunately, she was a perfectionist and became determined not to put on weight. She became anorexic in high school and continued with the problem at Stanford University, staying there almost two years. Finally, at forty, she returned to school and began studying on a veterinarian track and is loving it.

During my career years, there was no place for music, so at the beginning of my escapist retirement years on Block Island, when Janet suggested that I join the island's ecumenical choir, it made sense, and I did.

Tryouts for the choir consisted of showing up for rehearsal. If you couldn't keep up, you simply left. Reading music helped, but rehearsals accommodated those who could not. The choir put on seasonal concerts with sophisticated music and mini extravaganzas. These performances featured popular music done in skit form. Everyone had a solo at one time or another, and we had much fun. Some shows were replayed five or six times and drew capacity crowds. Our choir of thirty, plus or minus, consisted of some excellent singers and some that were aspiring.

I fell into the aspiring category, just trying at first to keep up and not embarrass myself. The purpose of the time I spent was not only social but also to appreciate the music and see what it and I had to offer.

As of this writing, I have participated for seven years in choirs and have learned to memorize, stay in tune, and sometimes lead my section. On the musical plane, I have learned how to prepare my voice for practice and performance. I have a somewhat hoarse voice, which, as I get older, seems to crack unless I have my honey and lemon before singing. I can stay with anybody holding a note eight beats and really enjoy much of the sound that we make. When we are good, we respect each other and become close-knit.

To provide support, Janet presented me with an electronic keyboard, and I have had a grand time using its different voices and styles. Whenever I get lost in the technology, I can press the button that says Grand Piano, and I am back to normal. With a book of children's songs written in simple music, I can actually perform accompanying group songs. Also, without the key board, I can sing on key and stay with a tune.

Of most importance, I have come to realize that my musical capacity is above average. What I can do brings me real pleasure, and I hope it also brings pleasure to those who take the time to listen. I have been generally unaware how many people can't sing but enjoy listening. Janet falls into that category. She loves music but can't carry a tune. She is, however, getting much better at singing "Happy Birthday," and there may be hope for further advancement.

Every once in a while, choir members check their ranges against the piano. Interestingly, I have added almost three notes to my upper range and perhaps one to my lowest.

Of most interest are the musical worms that lodge in my brain. As we get closer to a concert performance, tunes become imbedded in my head. I sing to myself on a regular basis in an instinctive, impromptu manner. I have, using music, been able to escape into the radiance of my own brain.

## Musical Capacity and Personality

As the world's population downloads music into portable electronic devices, one wonders what musical choices they have made, what they are hearing, and why they have chosen those particular selections.

Also, I wonder what I am missing.

I once got to know a talented high-school musician, Erica, who could remember visual scenes in musical notes and express her musical thoughts in words. I wonder how many people can do that. What can it be like living with such a head?

Erica looked out my office window and sang a song stimulated by the autumn foliage and promised to convert the song to a musical arrangement for her viola. She went on to Yale, where she continued her musical adventures.

Alicyn, in a similar vein, liked to compose music describing her visions. To this day, she remembers phone numbers by their touchtone musical values. Where am I on the continuum of ability to appreciate music? What could I discover about myself if I spent more time sampling and remembering types of music? Is my brain's musical file box more organized than I think?

Why aren't we spending time identifying and defining individual musical capacities at a young age?

The number of earbuds on the street would lead one to think that the general population is developing an increased appreciation for music.

I have some hearing loss in my right ear in the high range, which has helped me to understand the importance of my ears as a directional device. For instance, when my bird watcher friend points to a bush claiming that he hears an oriole, I can hear the bird but cannot locate it. My ears point me in the wrong direction, because they hear differently. I have, however, learned to identify and appreciate bird music as a symphonic experience.

The music of the world, particularly of a city with its array of cacophonous sounds, has its own beauty and is very much a part of harmonious living. I fall asleep on a boat when the slap of the waves and the banging of the rigging seem to be in tune. I enjoy the sound of a passing train whistle and a harbor foghorn even, I think, when I am asleep. These observations raise the question of how motion and music synchronize themselves in my head. To some extent, the music in an orchestra is enhanced by the motion of the violin bows and trombone slides. Why are we not taught to be more attentive to the nuances of sight, sound, and motion? How does watching a ballet fit into this appreciation picture?

How does our choice of TV programs fit into our personal array of sensual capacities and abilities? Soon, I assume, we will have smell emanating from the TV set. The whole sensual experience is driven to extremes with drug and alcohol enhancement. What does the artificial high stimulated by substance have to say about capacity and knowing the bounds and characteristics of our own minds? How does all of the above relate to sexual experience, and how does all of the above relate to having a healthy body?

Could it be that the holistic doctors of the future will write sensual prescriptions pragmatically developed to improve both the quality and longevity of human existence? I want to know more about my musical capacity as it relates to an ability to better understand and appreciate myself and others.

Most recently I have taken to playing with a hand bell choir. We wear gloves and preserve the quality of each bell with care. With some regularity, we produce pleasing sounds and harmony. A bell's sound is different and poses a whole new evaluation problem for my brain. One thing is for sure—much more can be done to help people understand music, particularly as it relates to understanding themselves. I am just starting to get to know the musical me. I am just starting to be able to escape into my musical self.

## Willy-Nilly Again

In order to cope with the ups and downs and in and outs of Block Island life, I must first recognize the permanence of the willy-nilly nature and then accept the roller-coaster ride as fun. In fact, the very nature and attraction of Block Island life is the unpredictable, often beautiful, and haphazard aspects of daily living.

## Winter on the Island—Time for a Change

It is winter, and my floating island is frozen in and loaded with snow. The geese are back sleeping on it as well as the seagulls and the mallards. Their swimming hole is open and dark blue in the long afternoon shadows, and twenty inches of snow are beginning to evaporate in the still-freezing cold and sharp sunshine.

I walk every morning with Sondi, my dog, where the wind is least pervasive and where the snow sculpture against the sea is most dramatic. I am the only one out on foot, and very few cars are on the road. We all wave, and I wonder if they can see my creepers. Made of bright pink plastic with mini road chains on the bottom, they pull easily over my boots and go well on snow ice or asphalt. I simply do not slip. But boy do I crunch. Today I have the camera, trying to find color and shape. The white drifts offset the branches' starkness, and the red winterberries pop out in all their virulence and unusual audacity. The

morning and afternoon lighting asks the gray shingle and white trim of our homesteads to step forth and claim themselves warm and comfy.

Sondi bounds though the snow, cavorting after her walk, and stops, having cornered a rat in the woodpile. She wants to play, and her eyes sparkle. She sniffs as we walk and thinks of the deer and dogs who have stopped to leave their marks. After four miles, she hasn't tired, and neither have I. It is the best part of the day.

The fact that there is nobody else on foot to enjoy this is sad and mystifying. If it feels so good, where is everybody? What rule is stopping them from being out? There are no footprints. There are very few driveway tracks. There is smoke coming from chimneys. Why are they in? Why aren't they out?

Seagulls are catching updrafts over the pond. They rarely move their wings and reach tremendous heights before sliding down quietly and gracefully. They aren't hunting. They aren't hungry. They aren't making love. They aren't cold. They aren't tired. They are gliding for the pure fun of it. They glide in a willy-nilly pattern that sends a message.

# Chapter 8
# ARIZONA

Working on the theory developed in the previous pages that escape is really from one mindset to another, Janet and I decided to move our winter home to Surprise, Arizona, which is about thirty minutes north of Phoenix and a few hours from the California state border.

> We purchased a small house with room for guests and started furnishing it with all the necessities.

Our contemporary style of decorating ran counter to the usual Southwest theme but seemed to be well received.

Sondi came with us and was given the run of the backyard, which we surrounded with a new fence. She spent many hours chasing rabbits as we watched for coyotes that were fully capable of jumping the six-foot fence.

Our close Block Island friends assumed that we were looking for a winter climate change, and to some extent, we were. But in reality, we just wanted another change as part of the escape mode of living, which seems to make our lives robust and viable. To answer the many questions about our move, we boiled it down to one catchy phrase. "We are moving for the adventure of it," we said.

## Art

Our new location is full of artistic and musical opportunity. I have changed my primary painting colors to reds and tans with some gold

now and then. My Arizona mountain ranges are much like Rhode Island's ocean waves.

Introduction by the Sun City Grand Art Club to liquid acrylic on Yupo paper made translation from the color images in my mind to paper much more meaningful and pleasurable.

This club, with a membership of more than three hundred artists, offers an air-conditioned painting studio and a wide variety of art lessons. Many of the artists are quite good, but they are better at painting mountains and desert flowers than boats and breaking waves (my forte). They laugh and talk as they paint, and they support my Eastern-style art.

## Music

The Sun City Grand Music Club has a 130-member choral group, which I enjoy. We put on sold-out concerts twice a year and go out to dinner with the proceeds to celebrate. One year the musical worms in my head picked up strands of *Phantom of the Opera* and played them back many times a day for many months. To sing something like *Phantom* with thirty other good bass voices was a thrill. Once again, this process allows my brain to expand and escape from its routine meanderings.

## Escape as a Transition

True productive escapes, I believe, relate to mental discoveries about your own brain. What do you really think? What do you really know? And how do you really feel? You don't escape from one place to another for mental relief. You enhance one mindset and join it with another to achieve relief.

How I see and feel a work of art and how I hear and feel a work of music will determine the extent to which I am able to escape mental quagmires. Being an artist and a musician in the last stages of my life seems to provide the essence of living and a true escape for me from the humdrum. The willy-nilly nature of life is pretty similar in both Arizona and Block Island ... both places offer wide ranges of opportunity where my mind can continue to grow, especially as it relates to music and art.

I also think that spontaneity created by a healthy, stimulated brain is the mother of creativity and associated escapist happiness. The greatest opportunity to extend a happy, escapist feeling for me is to share. If I can determine that someone really likes one of my paintings, I like to give it to them.

Finding extreme radiance for me is exploring fidelity and love with art and music.

## An Artist's Ultimate Escape

If you can join me in agreeing that the ultimate escape is a peaceful existence inside one's own head, if you can agree that art and music are among the good tools for enjoying the inner workings of your brain, then you may be able to understand the following conclusion: radiance is fidelity and love.

## My Family

My wife, my children, her children, and their children exhibit fidelity. In Wagner's opera *The Flying Dutchman,* the Dutchman searches for fidelity in love, which will allow him to escape the horror of life and appreciate the peace of death. As a painter, my ultimate goal, using charcoal, is to capture the radiance of my family fidelity on paper. I try to understand each of my family's faces and attempt to find the individual characteristics that combine to exude their radiances.

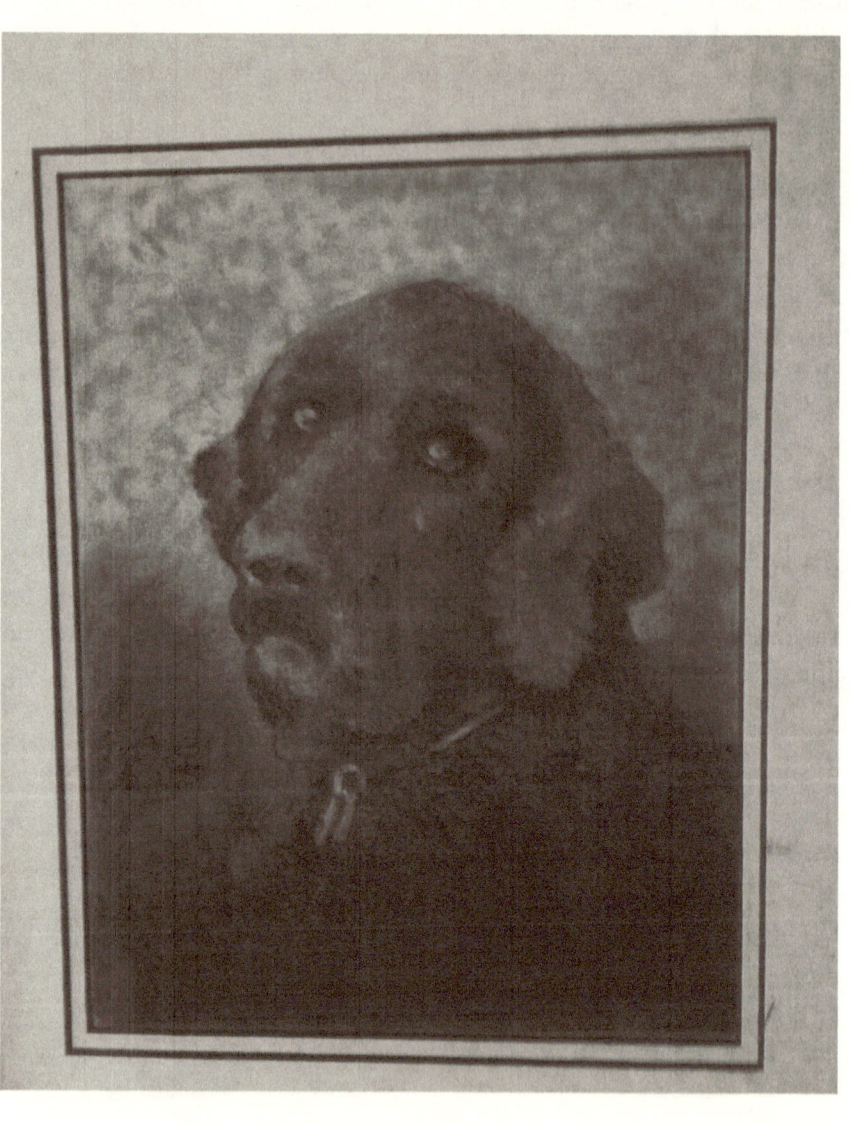

This photo is of an eleven-by-fourteen-inch rendering of Sondi in charcoal. It is an example of the type of rendering I would like to do of each of my family members.

In time, I will attempt to create paintings of my entire family: my eight grandchildren, three children, three step-children, and Janet. I will also start learning how to sculpt and translate the lessons learned in portrait painting to the molding of clay. The task of painting my family is daunting, but the process will be a true escape into my head and, if done according to plan, should produce an inner escapist peace. To capture the radiance of a family face will require in-depth thinking and associated artistic skill. During the process, it will not make any difference where I live. It will make a big difference how well I can learn to understand the radiance, fidelity, and love of each family member.

My definition of the essence of radiance relates to a special feeling that I have for my family. Your definition of radiance exists inside your own head and will take on the dimensions that you give it.

I am lucky to have a family of loving/beautiful people.

www.ingramcontent.com/pod-product-compliance
Lightning Source LLC
Chambersburg PA
CBHW021015180526
45163CB00005B/1969